5/01

D0764465

Keys to Painting
Textures & Surfaces

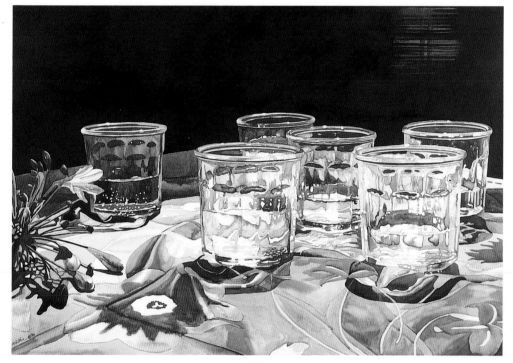

TERI STARKWEATHER
Full of Light
Watercolor, 30"×40" (76cm×102cm)

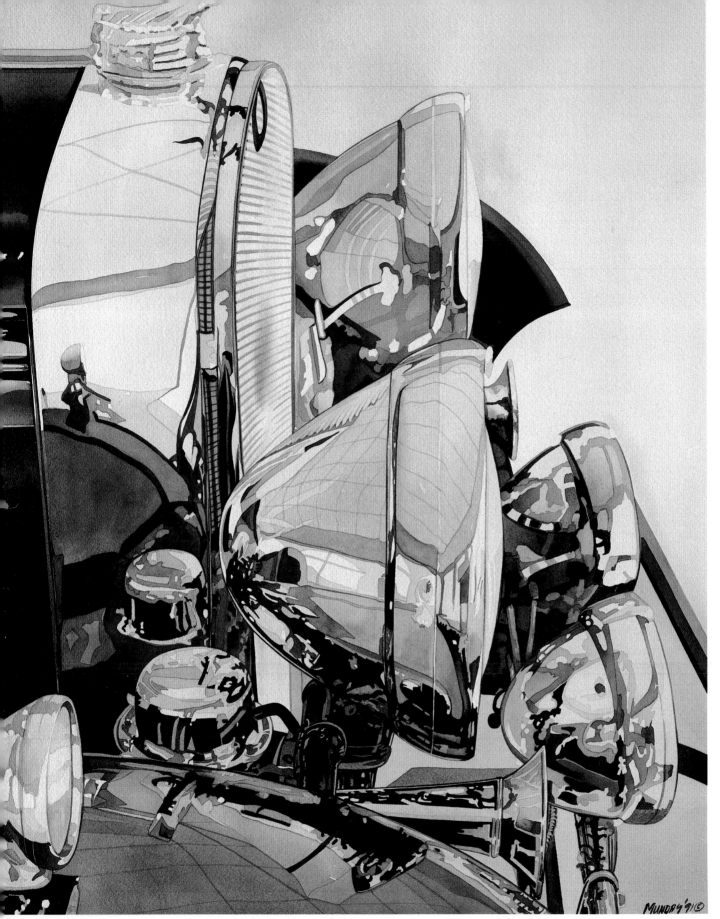

CHARLES W. MUNDAY
Caddy Chrome
Watercolor, 28"×22" (71cm×56cm)

Keys to Painting

Textures & Surfaces

EDITED BY RACHEL RUBIN WOLF

NORTH LIGHT BOOKS

CINCINNATI, OHIO

www.nlbooks.com

The material in this compilation appeared in the following previously published North Light Books and appears here by permission of the authors. (The initial page numbers given refer to pages in the original work; page numbers in parentheses refer to pages in this book.)

Dews, Pat. *Creative Discoveries in Watermedia* © 1998. Pages 46-59 (10-23).

Greene, Gary. *Creating Textures in Colored Pencil* © 1996. Pages 105 (114), 107-113 (115-121).

Heim, Dawn McLeod. *Step-by-Step Guide to Painting Realistic Watercolors* © 1997. Pages 32-39 (40-47), 56-65 (48-57).

Killeen, Earl Grenville with Leah Raechel Killeen. *The North Light Book of Acrylic Painting Techniques* © 1995. Pages 60-63 (122-125), 109-111 (73-75).

Nice, Claudia. *Creating Textures in Pen & Ink With Watercolor* © 1995. Pages 8 (25), 9 (half of 24), 12-13 (26-27), 22-23 (28-29), 26-29 (58-61), 32 (half of 24), 40-41 (76-77), 74-77 (78-81).

Pech, Arleta. *Painting Fresh Florals in Watercolor* © 1998. Pages 74-83 (62-71, backcover), 87 (72), 114 (8).

Purdon, Douglas. *Color Secrets for Glowing Oil Paintings* © 1998. Pages 98-109 (92-103), 112-113 (88), 114-115 (89), 116-117 (90-91).

Rocco, Michael P. *Painting Realistic Watercolor Textures* © 1996. Pages 44-47 (84-87), 70-73 (36-39), 108-109 (82-83).

Treman, Judy D. *Building Brilliant Watercolors* © 1998. Pages 82-85 (104-107).

Wolf, Rachel Rubin. *The Acrylic Painter's Book of Styles & Techniques* © 1997. Pages 88-93 (108-113).

Wolf, Rachel Rubin. *Painting the Many Moods of Light* © 1999. Pages 42-43 (30-31), 46-49 (cover, 1, 32-35).

Wolf, Rachel Rubin, ed. *Splash 4* © 1996. Pages 42 (6) *All Bottled Up* by Vivian R. Thierfelder, P.O. Box 3568, Spruce Grove, Alberta, Canada T7X 3A8; 83 (2) *Caddy Chrome* by Charles W. Munday, 632 Tanglewood Ave., Auburn, AL 36830; 88 (5) *Ready to Roll* by Peggy Flora Zalucha, 109 Sunset Ln., Mt. Horeb, WI 53572.

Keys to Painting: Textures & Surfaces. Copyright © 2000 by North Light Books. Manufactured in China. All rights reserved. No part of this book may be produced in any form or by any electronic or mechanical means including information storage and retrieval systems without permission in writing from the publisher, except by a reviewer, who may quote brief passages in a review. Published by North Light Books, an imprint of F&W Publications, Inc., 1507 Dana Ave., Cincinnati, Ohio 45207. (800) 289-0963. First edition.

Other fine North Light Books are available from your local bookstore, art supply store or direct from the publisher.

04 03 02 01 00 5 4 3 2 1

Library of Congress Cataloging-in-Publication Data

Keys to painting: textures & surfaces / edited by Rachel Rubin Wolf—1st ed.
 p. cm.
Includes index.
ISBN 1-58180-004-5 (pbk.: alk. paper)
 1. Still-life painting—Technique. 2. Texture (Art)—Technique. 3. Realism in art. I. Rubin Wolf, Rachel.

ND1390.K48 2000
751.4—dc21 99-055196
 CIP

Editors: Rachel Rubin Wolf and Stefanie Laufersweiler
Interior production artist: Kathy Gardner
Production coordinator: Sara Dumford

751.4
KEY
2000

ACKNOWLEDGMENTS

The people who deserve special thanks, and without whom this book would not have been possible, are the artists and authors whose work appears in this book. They are:

Lisa Buck-Goldstein

Phil Chalk

Pat Dews

Penny Saville Fregeau

Gary Greene

Dawn McLeod Heim

Earl Grenville Killeen and Leah Raechel Killeen

Charles W. Munday

Claudia Nice

Arleta Pech

Douglas Purdon

Michael P. Rocco

Teri Starkweather

Vivian R. Thierfelder

Judy D. Treman

Rachel Rubin Wolf

Peggy Flora Zalucha

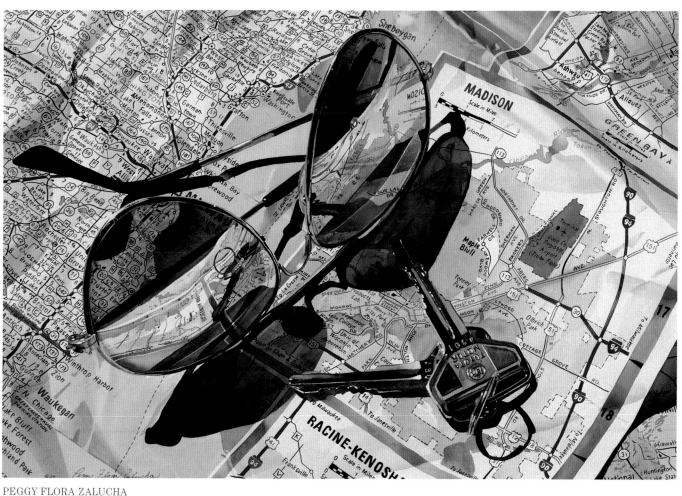

PEGGY FLORA ZALUCHA
Ready to Roll
Watercolor, acrylic and India ink
26" × 40" (66cm × 102cm)

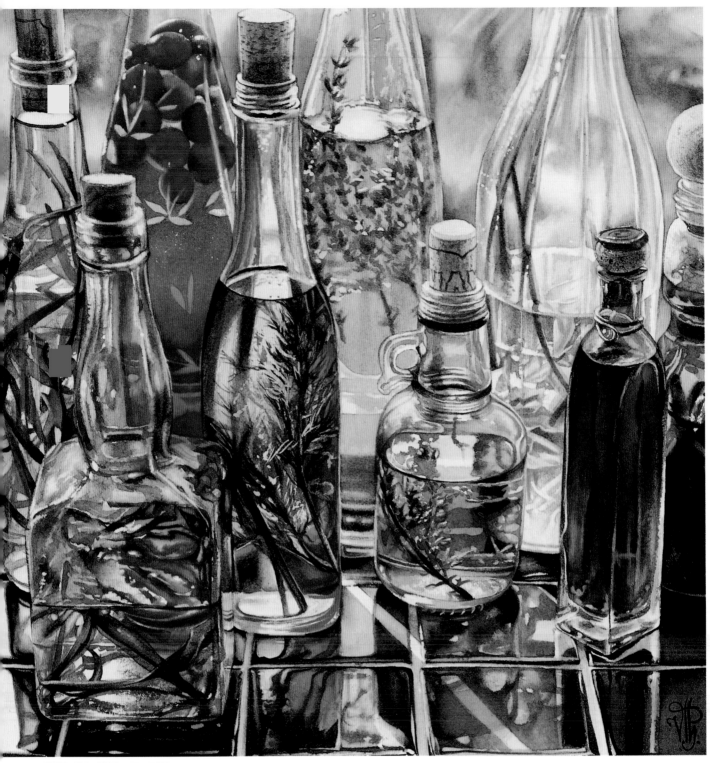

VIVIAN R. THIERFELDER
All Bottled Up
Watercolor, 8″×8″ (20cm×20cm)

TABLE OF CONTENTS

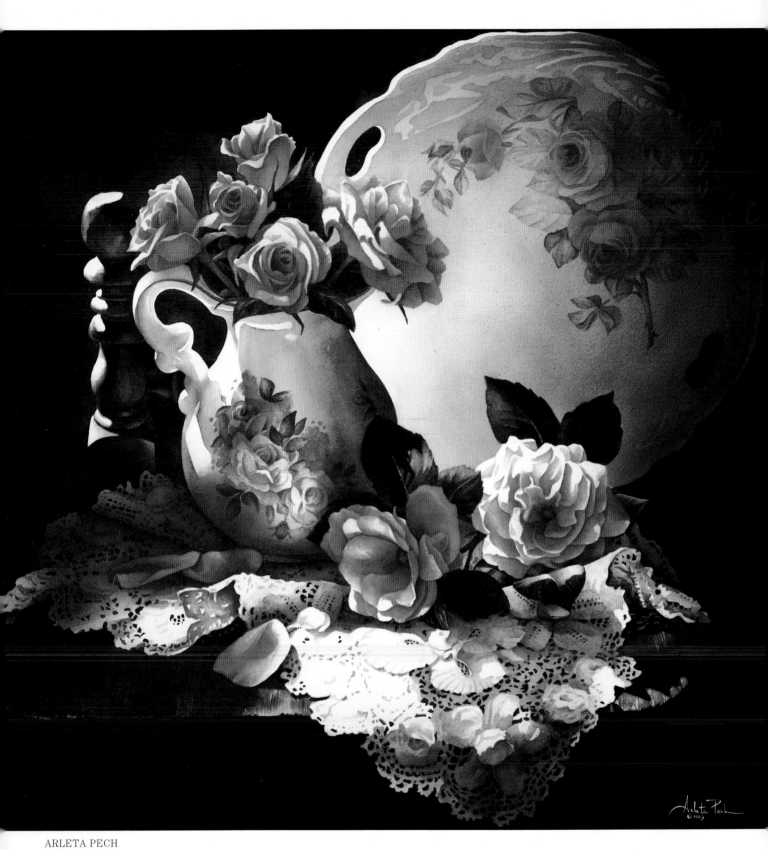

ARLETA PECH

A Touch of the Irish

Watercolor, 21½" × 22" (55cm × 56cm)

Courtesy of the artist and Mill Pond Press, Inc.

It is texture that breathes life into a painting; texture makes your subjects real. Texture helps to create rocks that are smooth and touchable or jagged and formidable; fruits that look ripe and delicious; crystal that refracts light and reflects brilliant colors. Texture adds character to a subject: The smoothness and intricate detail of an old, wooden carousel horse recalls the painstaking work involved in its creation; the tall spray created when a wave crashes against the earth reminds us of the great power of the ocean. Textural details add to the story a painting is trying to tell.

This book will show you the techniques you need to enhance your art with texture. You'll learn from the experts how to paint and draw a number of textures and surfaces in various mediums, including watercolor, acrylic, oils and colored pencil. Watercolorist Arleta Pech will teach you how to paint delicate, elegant lace. Gary Greene will show you how you can create the sheen of a shiny ribbon or the rusty look of an old door hinge with colored pencils. Douglas Purdon will show you how to create a rocky, lively seashore with oils. Following the simple, clear instruction of these artists and the many others in this book—and making your own adjustments and additions—will help your paintings come to life.

Creating Visual Textures

Texture Techniques for Watermedia and Acrylics

PAT DEWS

Hard Edge, Soft Edge

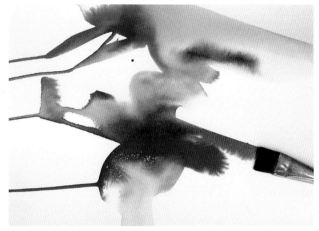

Wet part of the paper in a pattern, as if you were painting, and leave the rest dry. Then drop or paint your paint into the wet channels. You'll get a hard edge and a soft edge at the same time.

In this case, a bird-like shape was unknowingly painted. This shows that you can paint a shape with water and then fill it with color. This shape could stand separately in the painting.

Water Marks

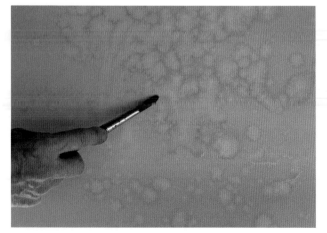

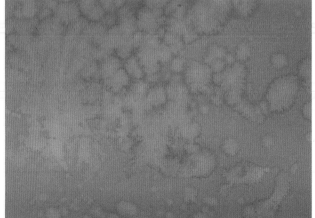

After dipping a small round brush in clean water, flick your wrist to let water spatter a nearly dry ink wash. If the wash is too wet, nothing happens. The size of the water mark depends on the size of the brush and the amount of water.

The resulting water-mark textures. You can use a toothbrush effectively as well. You can use this technique to make flower-like shapes, snow or just texture.

Alcohol Spritz

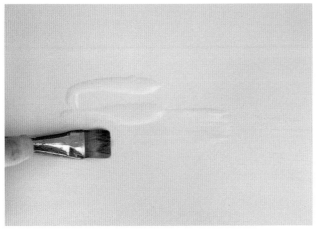

1 Spread acrylic gloss medium and varnish onto your paper. (The alcohol works best on a coated surface.)

2 After the medium dries, lay a wash of acrylic paint, which works well with alcohol.

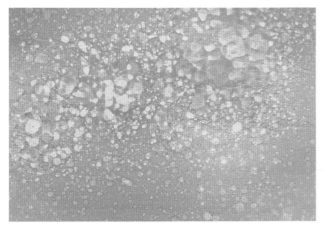

3 Spritz alcohol into the wet paint using a spray bottle filled with regular rubbing alcohol. The white surface of the paper will become visible.

4 Lay another acrylic wash.

5 Spritz again to reveal the yellow surface of the first acrylic wash and a little of the white of the paper. You can build up many layers of alternating color this way.

For rocks and water: Lay a wash of ink on Rives BFK printmaking paper, then spritz alcohol from a spray bottle into the wet wash. The paper makes dark spots where the alcohol hits it.

Salt Texture

Sprinkle regular table salt into a damp watercolor wash. (Be sure to let the wash dry slightly before sprinkling the salt.) Brush the salt away when it has dried. The salt absorbs the color. Be sure to remove all the salt so moisture doesn't accumulate.

In this example the salt was sprinkled into a much drier wash, so the spots aren't as large. For larger spots, salt a very wet wash or use kosher salt.

Bleach Texture

 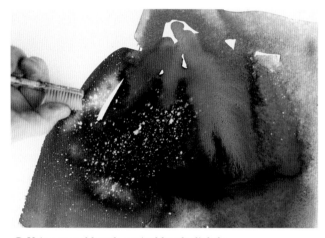

1 Paint a wash of ink, which seems to work best for this technique.

2 Using a toothbrush, spritz bleach slightly diluted with water.

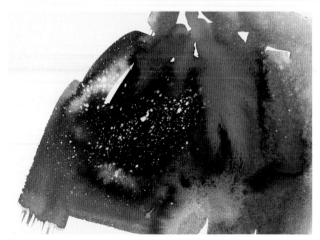

Bleach not only lifts color, it changes color.

TIP **DON'T FORGET** Be sure to use ventilation with bleach, place it in a marked container and keep it out of the reach of children.

Crackle Glaze Technique

1 Apply a wash of acrylic paint to illustration board.

2 Apply a thin coat of crackle glaze over the base color. Brush the glaze on vertically.

3 When the glaze is dry, brush on a top color horizontally. The thickness of the topcoat will determine the size of the cracks. Do not rebrush once cracks begin to appear. In subsequent layering, after the glaze with the cracks dries, too much water or layering will lift the crackle glaze. It's best to spray over it (which doesn't disturb it), leave it alone or make only one additional glaze—not too wet.

Wax Resist

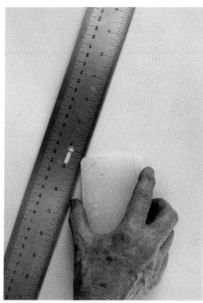

1 Using a ruler as a straightedge, guide a block of paraffin along the edge, drawing a straight line on the paper.

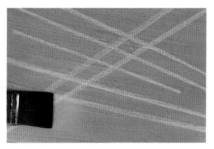

2 Lay a wash on the paper, and where the wax lines were drawn, the paint resists. Wax lines can easily make a grid pattern and interesting outlines.

Winsor & Newton Oil Vehicle No. 1

1 Apply the vehicle to the paper.

2 Lay a watercolor wash, and the paint skips where the vehicle is. Drop white arcylic ink into the wet wash, and the ink skips. The skipping action helps to create a sea-foam look.

> **TIP USE WAX RESIST FOR FOAM IN WATER**
> Wax resist is a good technique to use for a foamy seascape. Simply rub paraffin over your paper in a loose manner, and then sweep one or two watercolors over the area with a wide brush (Dews uses a 2-inch [51mm] Robert Simmons Skyflow brush). Wherever the paint touches the wax, it resists, capturing the look of foam.

Taped-Line Technique

1 Stick a piece of masking tape on your painting surface. Brush acrylic gloss medium over the tape to prevent the paint from seeping under the edges.

2 Paint a wash over the tape.

3 When the paint dries, peel off the tape. Pull it off gently using a finger to hold the tape down as you pull so the tape doesn't rip the surface.

Plastic Wrap Texture

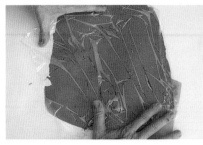

1 Paint a watercolor ink or acrylic wash onto your paper. While still wet, place plastic wrap into the wash; the paint must be wet to create texture. You can direct the design by manipulating the plastic wrap. If the wash is too wet, you can lift the excess paint with the plastic wrap and make the texture by placing the wrap on a clean surface; this is one way of making a transfer (see page 19). Plastic wrap of a heavier weight works best.

2 When the paint has dried, remove the plastic wrap. Most often (but not always) the image will be linear. With certain colors and inks you get a shiny surface on your paper, making a nice contrast. Different papers will texture differently.

Waxed Paper

A similar effect can be accomplished by placing waxed paper into a wet wash. Wax is left on parts of the paper, causing the paint to skip and not completely adhere— very useful for foamy seascapes. For a softer looking texture, remove the waxed paper before the paint is completely dry or use an uncrumpled sheet.

TIP REMOVING WAXED PAPER
Remember that drying varies with the fluidity of the paint. Check and don't wait too long or the paper could be hard to remove. A single-edge razor is handy for lifting a stuck edge.

Toilet Tissue Lift

1 Roll out toilet tissue onto a wet acrylic wash. This is a great way to lift excess paint or lighten a passage.

2 Lift the tissue immediately to reveal an even pattern of paint. Any texture on the tissue transfers to the paint; paper towels work well for this. You can make curves by rolling the paper in a wave-like pattern.

Bubble Pack Texture

1 Press bubble pack with large bubbles into a wet watercolor wash.

2 When the paint is dry, remove the bubble pack, revealing a honeycomb print.

Here's an example of the texture made with bubble pack with smaller bubbles.

String Line

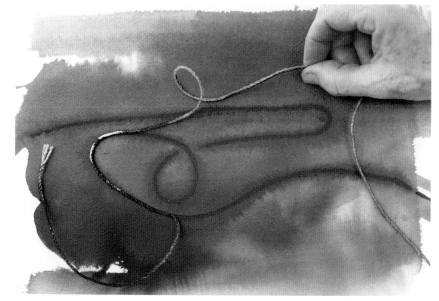

Place a string into a very wet wash. Paint over the string and remove the excess paint (or leave the excess for a water-mark halo effect). When dry, lift the string and reveal the print.

Masking Tape Stencil

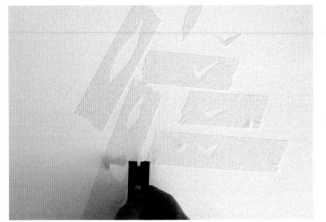

1 Cut a stencil from masking tape using a single-edge razor blade. Cut gently or you'll cut the paper, too.

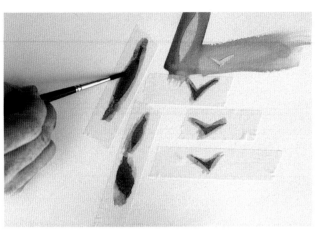

2 Paint the exposed shape. This example used watercolor, and gouache works well, too.

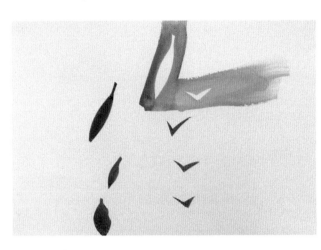

3 Remove the tape to reveal the stenciled shapes. If you use opaques, you can place any shape over an underpainting.

Mat Board Straightedge

1 Place a leftover mat board scrap on your paper and apply acrylic paint (made opaque with a little gesso). Use a sponge brush for a flat, even coat; a regular brush would allow paint to seep under the board's edge.

2 Remove the board to reveal the straight edge painted on the paper.

Stencil Lifts

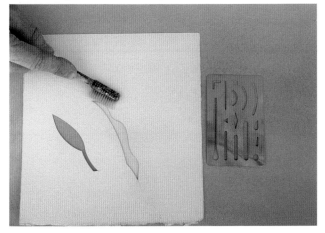 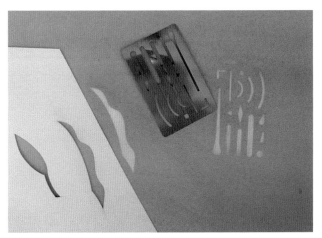

1 With a single-edge razor blade, cut a stencil shape out of watercolor paper (or use stencil paper). On a prepared watercolor wash, use a toothbrush dipped in clear water to scrub and lift the stencil shape (for fragile paper, use a natural sponge). A staining color will not lift to the white surface, but you will see a variation; acrylic won't lift at all. You can also lift using an erasing shield. Wipe up excess water with a paper towel before removing the stencil.

2 Remove the stencil to reveal the lift. You can use this technique to put a sailboat in water, a seagull in the sky or clothes on a line. The edge is softer than you'd get from liquid mask. The erasing shield is great for lifting little highlights.

Simulated Collage Edge

1 Tear a paper stencil that has a ragged collage-like edge.

2 Paint the edge with opaque paint. You can use this technique in either watercolor or acrylic. (Acrylic was used for this example.)

3 Remove the stencil, and you have a painted collage-like edge. If you paint over the entire paper stencil, it will appear you collaged on a piece of paper.

Sponge Painting

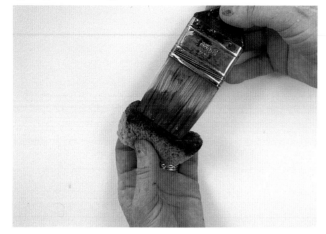

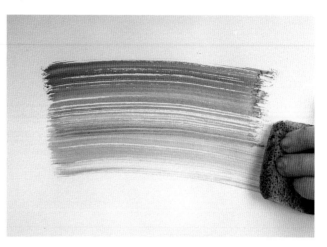

1 Apply watercolor paint to a slightly damp natural sponge and gently sweep across dry paper.

2 Apply a second color and paint next to the first. This is a great way to texture old crocks and vases. A little tooth-brush spatter would create a pottery-like texture. It's a good way to render old barn boards, too.

Sponge Printing

1 Press paint into your sponge.

2 Press down and rub the back of the sponge to leave an imprint.

This texture would work for a building or stone wall. Different sponges make different textures.

Waxed Paper Transfer

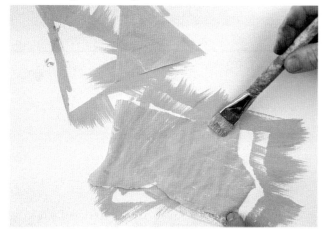

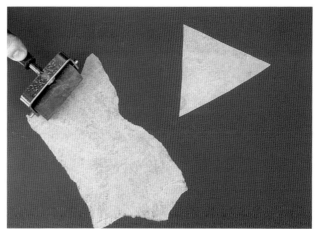

1 Cut a shape out of waxed paper and use a flat brush to paint it with an opaque acrylic.

2 Place the painted shape on a prepared surface and apply pressure with a brayer. Wipe up any excess paint immediately before it dries and can't be lifted.

3 When dry (the paint dries fairly quickly), lift the waxed paper shape. The shape is now on your board. For a more solid shape, apply thicker paint. This is a good technique for making color and value changes.

Plastic Wrap Transfer

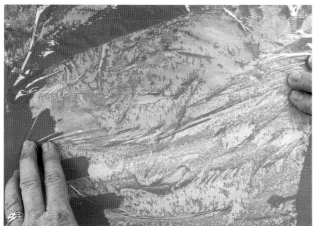

1 Paint opaque acrylic onto plastic wrap and press it onto a painted acrylic or watercolor surface.

2 Remove the plastic wrap when the paint is dry; the texture transfers to the board. Some artists use this technique for color and value changes or to apply paint to a blank surface.

ALBUQUERQUE ACADEMY
LIBRARY

Brayer

 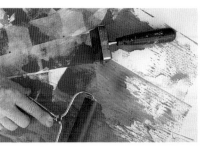

1 Pour a puddle of acrylic paint and roll the brayer in it to pick up the paint.

2 Roll the brayer on your paper, making a roller print. Use brayers of different sizes for interesting effects.

Brayer prints vary from roll to roll when you use the paint transparently. You have more control with opaque paint, but you don't get the interesting texture.

Paint, Transfer, Print

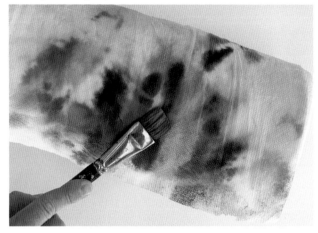 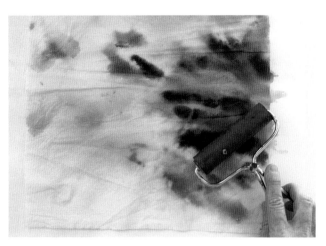

1 As you paint and change color, wipe your brush on a paper towel before going into a new color. This paint is deposited onto the towel.

2 While the paint is still wet, place the paper towel on a white surface and roll a brayer over it to transfer the color.

3 Remove the paper towel to see the textured print.

Pencil Work

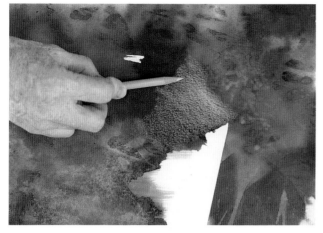

Holding the point sideways, rub a pencil in such a way that the underpainting is allowed to show through.

The pencil is much easier to use for certain line work.

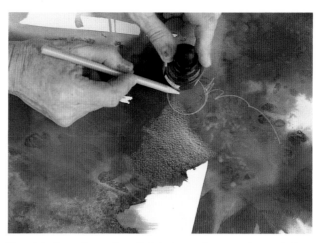

Use objects such as a jar of ink to trace shapes onto a painting.

Caran D'Ache Neocolor II Aquarelle Crayons

1 Have fun and lay down some free, loose line work with the crayons.

2 Wet the crayons with clean water to activate them.

3 When dry, the result is an interesting combination of water-color wash and line work.

Cheesecloth

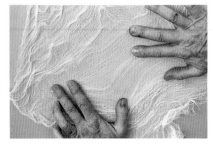

1 Manipulate cheesecloth, separating the weave to form interesting patterns for a fabric print.

2 Place the cheesecloth on your surface and brush ink through it—use a lot so the cloth rests in liquid. This will cause a dark mark; brush lightly and the cloth will act like a stencil.

3 Lift the cheesecloth after the ink has dried. This technique works very well with nautical themes.

Facial Tissue Texture

2 When the paint is almost dry, remove the tissue. The timing has to be right or the tissue will stick. If it does, re-wet the tissue carefully and lift.

1 Place a dry facial tissue on your paper, then apply watercolor paint through the tissue. (Don't use acrylic, or the tissue will be glued down.)

Painting Through Rice Paper

1 Assemble your papers and ink, and paint through the rice papers. Rice papers are great to paint or spray through or place in wet washes. They all texture differently.

2 Remove the papers and notice the different finishes. The difference is from the amount of ink and water.

Razor Blade

1 Dip your single-edge razor in a paint puddle. A worn blade works better since the surface is not as slick and the paint adheres better.

2 Manipulate and twist the blade to make shapes.

Many shapes are possible with practice. This technique is great for making trees, sailboats and shell shapes.

Brush Handle

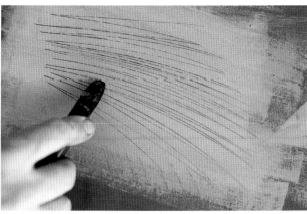

Apply an opaque (gesso and acrylic) wash over a dark background. The slanted end of a 1-inch (25mm) aquarelle brush can be used to scrape through the color, revealing the underpainting. You can also scrape out trees, grass and other shapes. This also works in watercolor, but the paint must be nearly dry before scraping or you will get a dark line when pigment settles into the scraped line.

Palette Knife

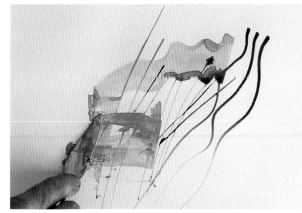

Here are some of the textures you can get using a palette knife. Pick up paint with your palette knife, and apply it with the edge, tip and flat edge.

Basic Texture Techniques in Pen and Ink With Watercolor

Pen and ink is a common texturing medium. Dots and lines can be varied in size, volume, arrangement and form to create the appearance of texture. There are seven distinct texturing techniques: contour lines, parallel lines, crosshatching, dots or stippling, scribble lines, wavy grain lines and crisscross lines. These techniques may be used separately or combined to produce countless effects. When the texture of pen work is desired, but India ink lines are too prominent, earth-tone mixtures of liquid acrylic may be substituted in the pen.

Watercolor is subtle in its display of texture. However, the softer look of brush-produced strokes and "water flow" textures are greatly enhanced by the impact of color. Dynamic choice of hue can "wake up" a tenuous texture to produce striking realism. Watercolor texturing depends greatly on the reactions of pigmented washes to dry, damp and wet paper surfaces. The wetter the surface, the softer and more free-flowing the applied paint will become. The use of various brushes and tools to apply (or remove) the paint is equally important to the creation of textural effects. Application techniques include stroking, scraping, spattering, stamping and blotting. Salt, liquid frisket, alcohol, plastic wrap and plain water can be used to alter the distribution of the pigment, producing even more visual variants.

By combining the boldness of pen and ink, the subtle qualities of watercolor and the visual impact of color, the creation of texture is only as limited as your imagination.

right
CLAUDIA NICE
Canyon Walls
Pen work overlaid with watercolor
9½"×7" (24cm×18cm)

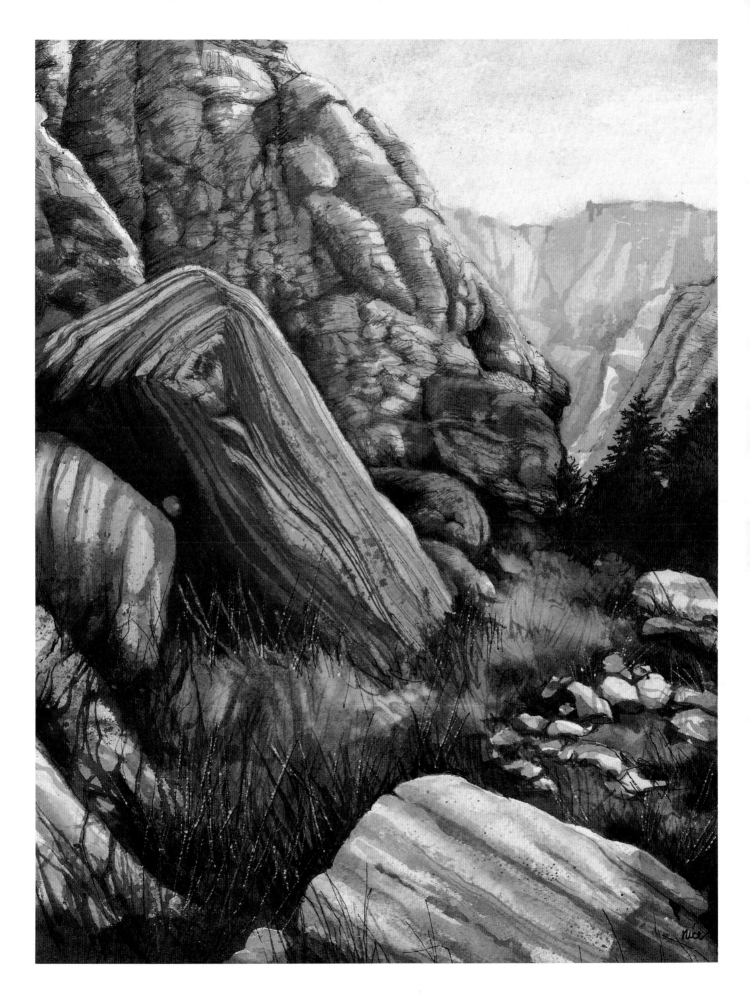

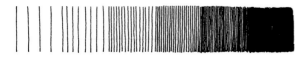

Value deepened by stroking lines closer together

VALUE

Value is the degree of lightness or darkness in a color. India ink work has a palette ranging from white through the various gray tones to black. The more marks added to the paper surface, the greater the degree of darkness.

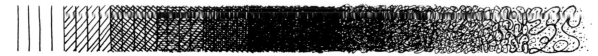

Value deepened by layering sets of pen strokes

Value deepened by combining different texture layers

Subtle blending of values

Stippling provides the most delicate means of blending value using pen-and-ink techniques.

CONTRAST

Placing dark objects against lighter backgrounds and vice versa provides a natural edge where the two values meet. The greater the contrast between the two values, the more distinct the form of the object will become. Contrast is the key to a well-defined art piece.

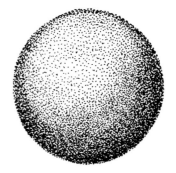

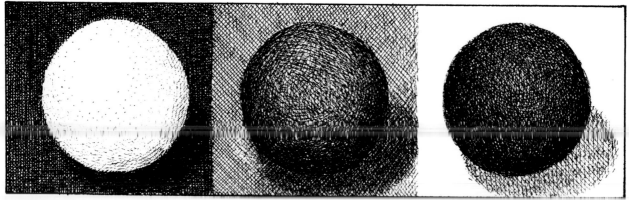

Shapes defined by contrast of value

TECHNIQUES FOR DEVELOPING CONTRAST AND DEFINITION

Pen and Ink

Brush and Watercolor

Contrast of value

Contrast of value

Contrast of texture

Contrast of texture

Line direction variation

Stroke direction variation

Nib size variation

Brush size and shape variation

Color variation

Color variation

Combining Pen, Ink and Watercolor

CLAUDIA NICE

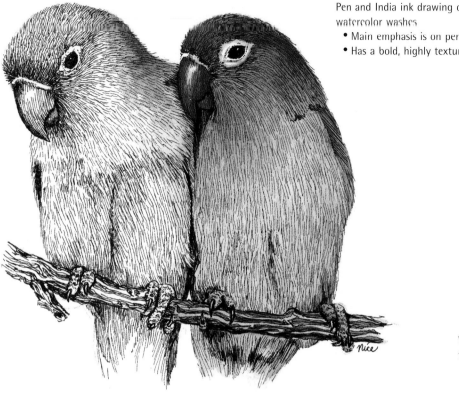

Pen and India ink drawing overlaid with watercolor washes
- Main emphasis is on pen-and-ink work
- Has a bold, highly textured appearance

Watercolor painting overlaid with pen-and-ink texturing
- Main emphasis is on watercolor brushwork
- Tends to be more spontaneous and delicate when brushwork is done before pen work

The addition of India ink marks lends texture and substance to the clouds, rocks and waves.

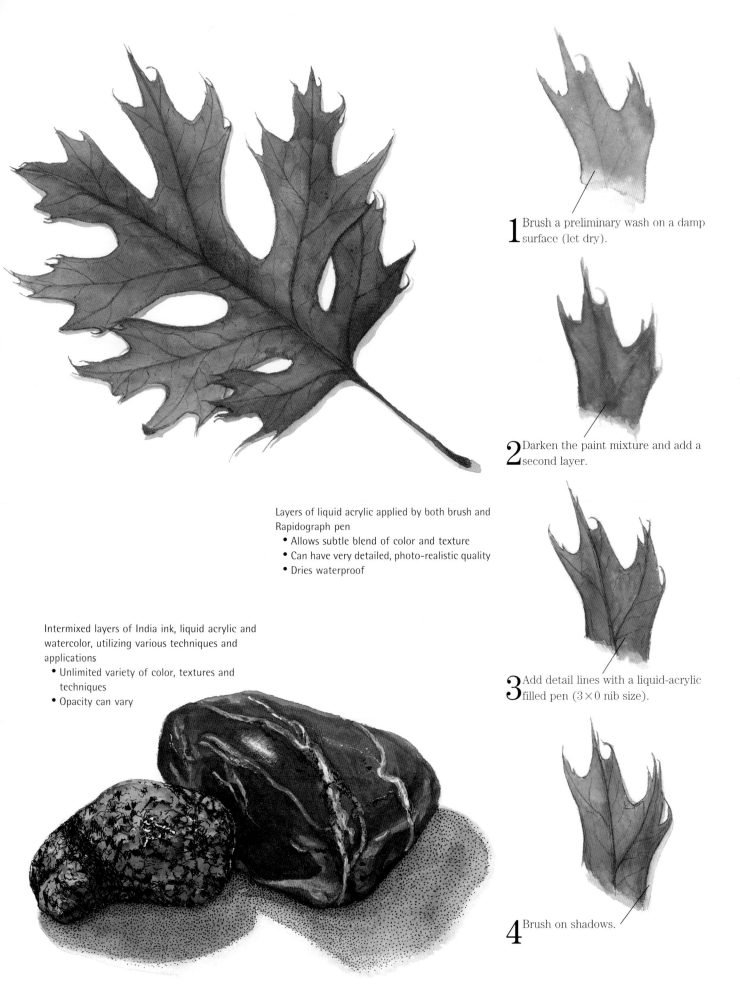

1 Brush a preliminary wash on a damp surface (let dry).

2 Darken the paint mixture and add a second layer.

3 Add detail lines with a liquid-acrylic filled pen (3×0 nib size).

4 Brush on shadows.

Layers of liquid acrylic applied by both brush and Rapidograph pen
- Allows subtle blend of color and texture
- Can have very detailed, photo-realistic quality
- Dries waterproof

Intermixed layers of India ink, liquid acrylic and watercolor, utilizing various techniques and applications
- Unlimited variety of color, textures and techniques
- Opacity can vary

Painting Glass and Other Transparent Surfaces

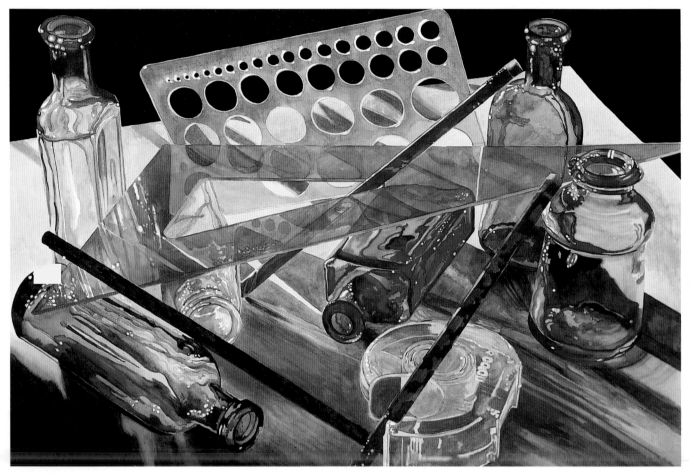

TERI STARKWEATHER
Geometric Romance
Watercolor, 20" × 30" (51cm × 76cm)

The late afternoon sun creates long, dramatic and colorful shadows. Transparent colored objects both reflect light and affect light by changing its color.

Transparent Objects in Window Light

Artist Teri Starkweather brings together a number of transparent objects and sets up her arrangements in front of a window. She uses only sunlight, and prefers low morning and afternoon light because it streams more directly through the window. She works almost exclusively with backlighting, because it shows off the transparency or translucency of the objects.

She uses no masking, preferring to save whites as highlights, and paints methodically, usually completing one object at a time. Starkweather never uses black or white, but keeps the paint as transparent as her objects.

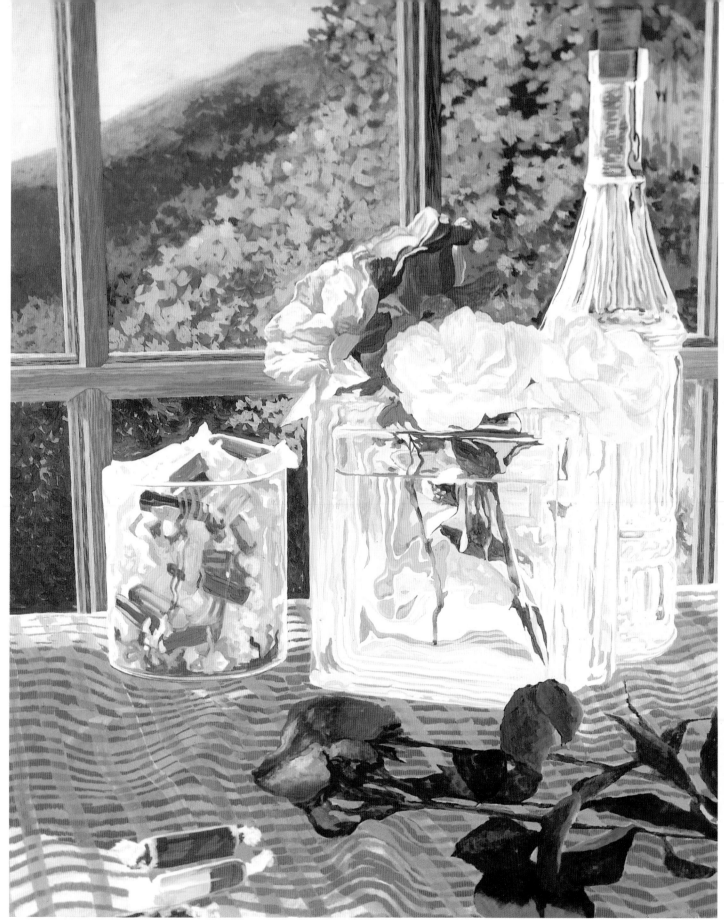

TERI STARKWEATHER
Candy and Roses
Acrylic, 40″×30″ (102cm×76cm)

The clear glass objects here are made interesting by painting carefully observed bits of color, picked up from surrounding objects.

More Transparent Objects in Watercolor

TERI STARKWEATHER

Observe Your Reference Carefully

To complete glass objects and their contents, work slowly and carefully, studying your reference (whether live or in a photo) for all the intricate light and dark shapes that, when rendered faithfully, create the illusion of glass or other textures. Use a lot of colors in a careful wet-into-wet blending technique.

> **TIP** **OBSERVE LIGHT'S INTERACTION WITH OBJECTS**
> Light cannot truly be seen unless it reacts with objects, whether the surface of the moon or transparent and translucent objects closer at hand. To make transparent objects look "real" in a painting, carefully study the light and dark shapes and patterns and the bright highlights created by light passing through and bouncing off these surfaces.

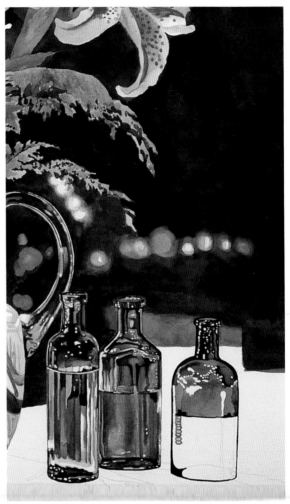

Leave Reflective Stripes on Bottles

To show light reflecting off glass, as with the window light reflected off the bottles pictured here, leave one or more white vertical stripes along the sides. Observe lights and darks carefully, and add darks on the bottoms of bottles.

TERI STARKWEATHER
Sunshine and Roses
Watercolor, 40"×30" (102cm×76cm)

Use Paper White for Light
Here, Starkweather leaves the bright white of the paper directly underneath the pitcher to indicate light passing through the glass. She then glazes the area with a light Aureolin wash for a warm glow.

TERI STARKWEATHER
Window Arrangement
Watercolor, 40"×30" (102cm×76cm)

Light Defines Transparency

These glass objects were placed on a kitchen window ledge in the morning sun. The translucency of the rose petals is made apparent because of the strong backlighting. The light pastel-colored washes in the bottle reveal the texture of the thicker patterned glass that reflects light as much as it allows light to pass through it. Both glass pieces contrast sharply with the dark, shadowy background.

A Colorful Surface Plus Clear Glass

Setting up water glasses outside in the summer sun with a colorful silk scarf underneath allows interplay of glass, light and color. This combination gives a full range of interesting textures, from two kinds of transparency (glass and water) to the visual texture of a colorful pattern on a flat surface.

TERI STARKWEATHER
Full of Light
Watercolor, 30" × 40" (76cm × 102cm)

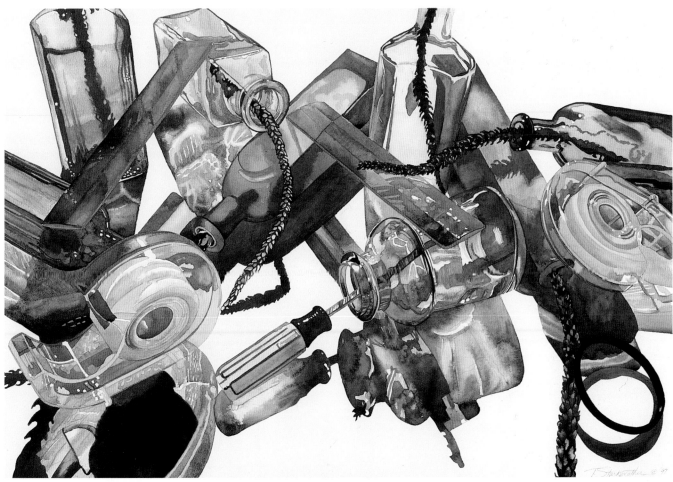

TERI STARKWEATHER
Accidental Love
Watercolor, 18" × 26" (46cm × 66cm)

Direct Lighting for Strong, Colorful Shadows

This playful painting is full of surprises from the color, transparency, shadows and organic plant forms. The direct light source creates strong, colorful shadows and an abstract quality. The objects were set up outside on white paper. The long, colorful shadows are really half shadow and half filtered light. Playing with color and transparency in sunlight offers an endless range of interesting surfaces.

Painting Stained Glass

MICHAEL P. ROCCO

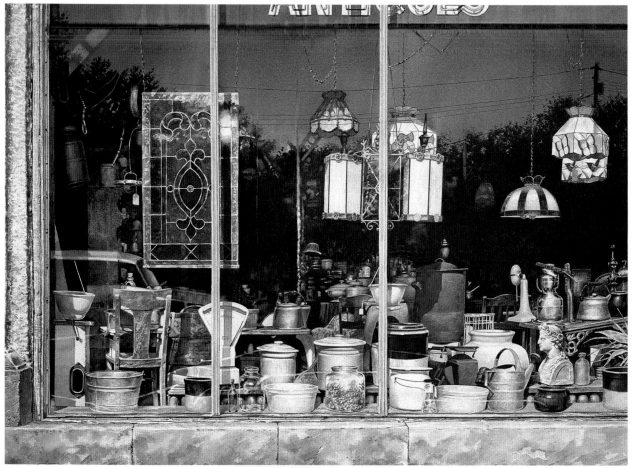

MICHAEL P. ROCCO
Reflections of the Past
Watercolor, 21"×29" (53cm×74cm)

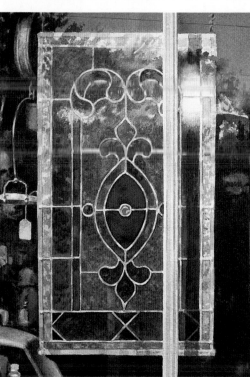

DETAIL OF STAINED GLASS PANEL

For this demonstration, artist Michael P. Rocco renders only the top left portion of the stained glass panel in his painting *Reflections of the Past*, which shows an antique shop window.

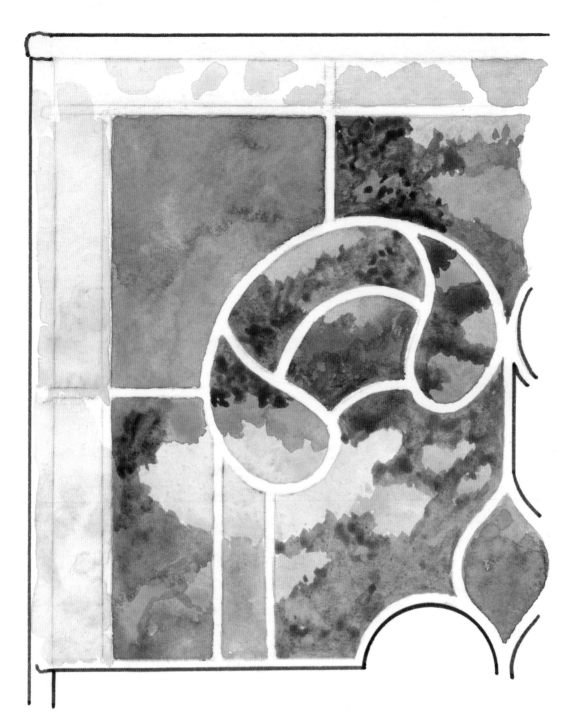

1 The dark outline is merely for definition of the panel. Begin by painting basic light areas in each section, then surround these with appropriate colors. The darker tones are caused by reflections of a tree on the panel. Apply some colors wet-into-wet to get variations in the blend. Add deeper tones throughout to simulate the uneven surface of the glass.

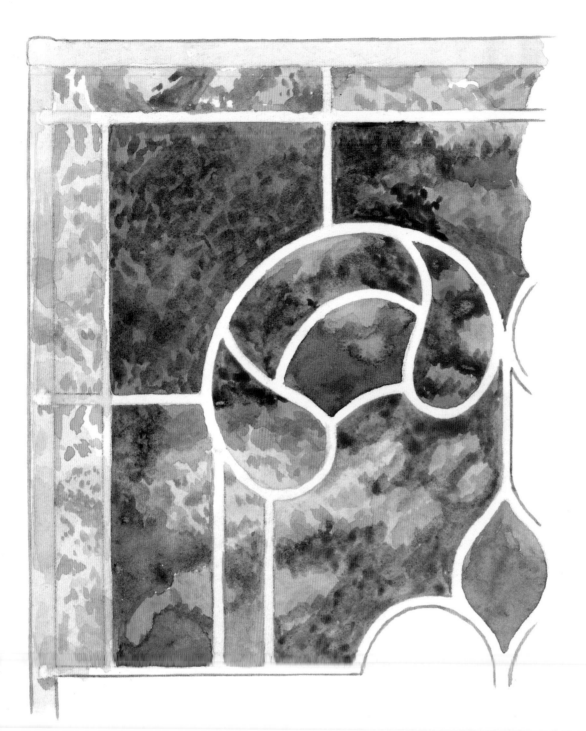

2 Continue to develop the rippled glass with additional deep tones, and carry the texture into the lighter areas. Soften harsh edges by washing away color and blending. Paint the outer frame and some of the shadows on it caused by reflections.

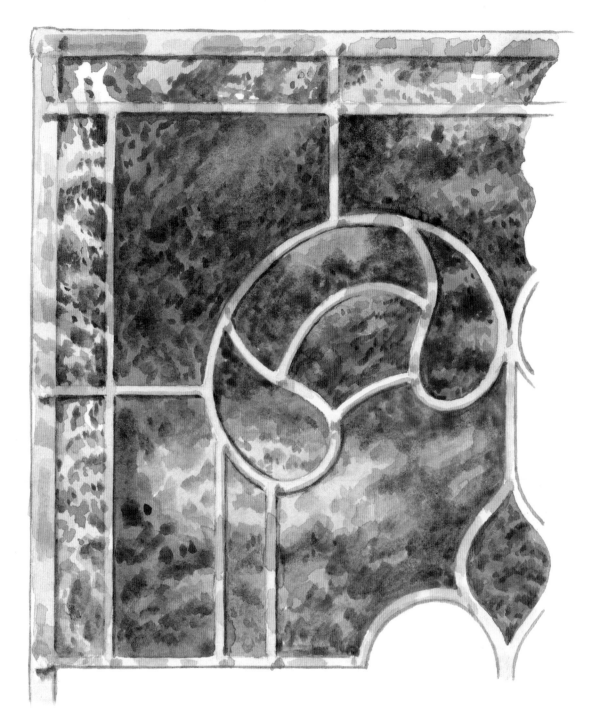

3 Finish accenting ripples in the glass using dark tones of the color used in each section. The leading of this panel has a pale green patina, which is fortunate because the light color helps the definition. Shadows fall all over the panel, so paint these to assist the continuity of the reflections. With thin lines, accent the dimension of the leading, putting in shadows especially at soldered joints. This stained glass panel has no backlighting, and its color differs greatly from the illuminated hanging lamps in the finished painting.

Painting a Stained Glass Iris

DAWN McLEOD HEIM

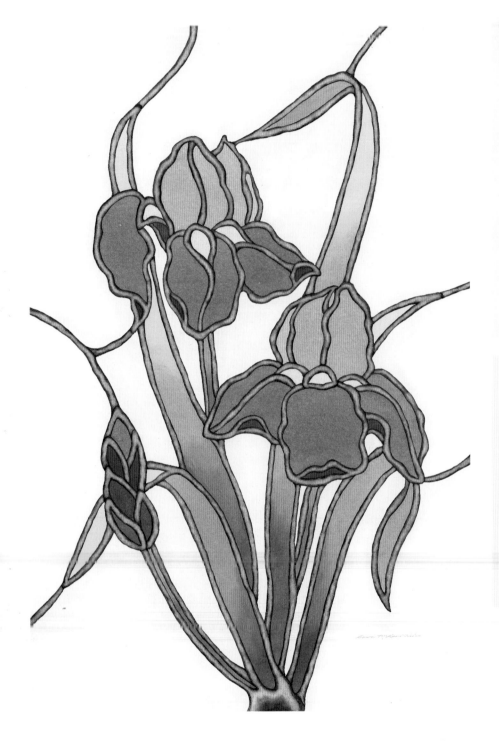

MATERIALS

Daniel Smith paints
- Cobalt Blue
- Carbazole Violet
- Hansa Yellow

Winsor & Newton paints
- French Ultramarine
- Permanent Sap Green
- Winsor Blue
- Cadmium Yellow
- Neutral Tint

Brushes
- No. 8 round (for lead)
- No. 10 or no. 12 round (for petals, leaves and background)

Other
- A half-sheet (22″ × 15″ or 56cm × 38cm) Arches 300-lb. (640gsm), cold-press watercolor paper

COLOR KEY

A Cobalt Blue + Carbazole Violet (light/medium)
B Cobalt Blue + Carbazole Violet (medium)
C French Ultramarine + Carbazole Violet
D Cadmium Yellow + Hansa Yellow
E Hansa Yellow + Permanent Sap Green
F Permanent Sap Green
G Permanent Sap Green + Winsor Blue
H Cadmium Yellow
I Neutral Tint

The pattern artist Dawn McLeod Heim uses for this project is an adaptation from actual stained glass windows designed by Judy Miller. This project was created especially for beginners. The flower shapes are large and easy to block in with color using the controlled wash technique. The leaves are long and narrow to make the charging of colors easier and more manageable. If you happen to go slightly outside the lines while painting the flowers and leaves, the lead design helps to conceal any imperfections.

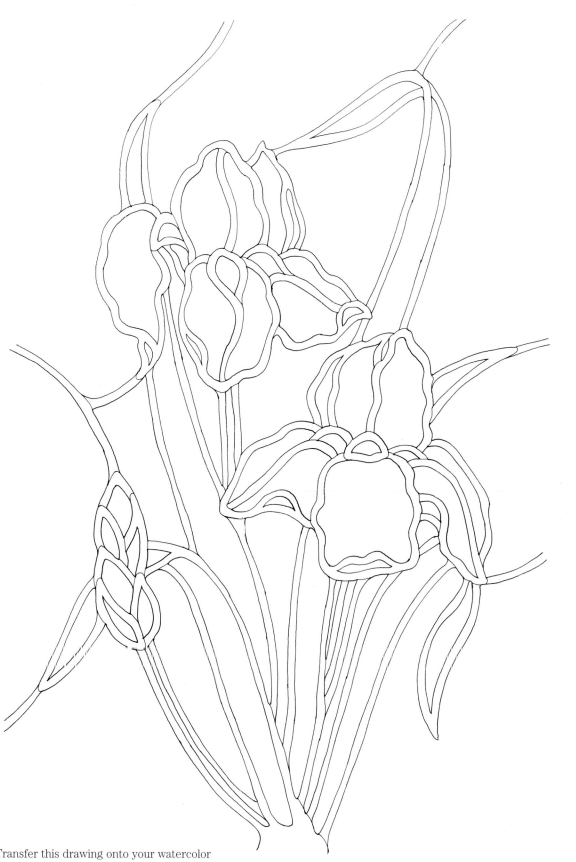

A

B

C

D

E

F

G

H

I

Transfer this drawing onto your watercolor
paper, enlarging or reducing it as needed.

PAINTING THE FLOWERS AND LEAVES

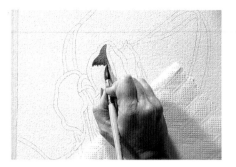 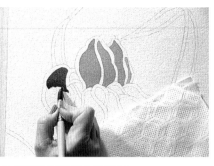

1 PAINT TOP PETALS OF IRISES
Paint the iris at the top first. Fully load your brush with **A** and paint a section of the petal using the controlled wash technique. Let dry. Paint the next section of the petal in the same manner, and continue until all the top petals on both irises have been painted.

2 PAINT BOTTOM PETALS
Paint the iris at the top first. Fully load your brush with **B** and paint a section of the petal, using the controlled wash technique. Let dry. Continue painting until all the bottom petals on both irises have been painted. With **B** still in your brush, paint the small section of the iris bud on the lower left side. Let dry.

3 PAINT DARK SHADOWS
Load your brush with **C** and paint all the dark shadow shapes on the lower petals, starting with the iris at the top. With **C** still in your brush, paint the two small sections of the iris bud on the lower left.

4 PAINT SMALL YELLOW SHAPES
Load your brush with **D** and, starting with the iris at the top, paint all the small yellow shapes as shown in the sample. Let dry.

5 PAINT LEAVES
Paint the tall leaf on the left side of the top iris first. Fully load your brush with **E** and paint the top section of the leaf. Let dry. Fully load your brush with **E** again and, starting below the iris petal, continue to paint with **E** as far as the sample shows you to. Next, fully load your brush with **F** and charge **F** into **E** as far as shown. Then, fully load your brush with **G** and charge **G** into **F**. Finish painting the leaf with **G**. Continue painting the leaves using the color squares and the sample at right to help guide you on which colors to use. Let each leaf dry before painting the next one.

TIP CHARGING COLORS
Charging creates a gradual color change without hard edges. For this technique fully load your brush with the first color and apply droplets horizontally in a continuous manner (this is called a "bead"). Next, fully load your brush with a different color, lightly touch the bead, and lift your brush to let the color release. Continue this along the entire bead. Then load your brush with the second color again and charge into the second bead. Mop up any excess color.

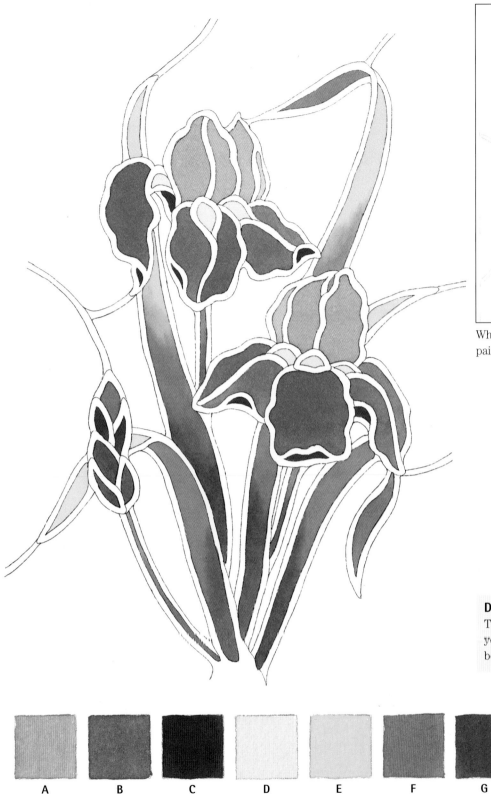

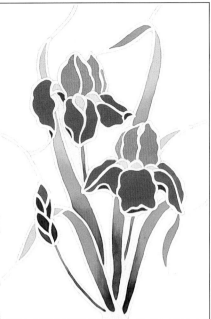

When you are finished with steps 1-5, your painting will look like this.

DON'T FORGET
To keep clean colors, remember to rinse your brush in clean water and blot well before using a new color.

| A | B | C | D | E | F | G |

PAINTING THE BACKGROUND AND THE LEAD

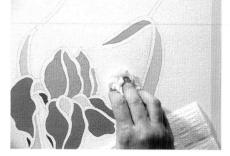

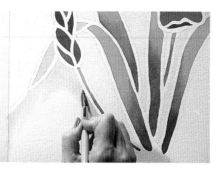

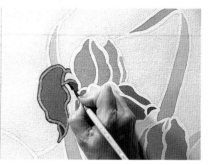

6 PAINT INSIDE AREAS OF BACKGROUND
Fully load your brush with **H** and paint one of the solid yellow areas shown in the sample. When the sheen is almost gone, lightly blot the area with a tissue to create texture. Let dry. Continue painting in the same manner until all the inside areas have been painted.

7 PAINT OUTSIDE AREAS OF BACKGROUND
Paint all the outside areas next, starting with the lower left side. Fully load your brush with clean water, and really wet the entire area, stopping about a half-inch (1.3cm) from the lead line. While the water still has lots of sheen, fully load your brush with **H** and paint along the lead line and toward the water, allowing **H** to charge into the water.

Continue to paint along the lead line with **H** until that entire section has been painted. When the sheen is almost gone, lightly blot with a tissue. Let dry. Continue to paint in the same manner until all the outside areas have been painted.

8 PAINT LEAD
Paint all the sections of lead around the irises first, and then the leaves, following the directions given in the sample below. Let each section dry completely.

Use very short, bouncing brushstrokes as you move your brush down the center of the lead. Make sure the strokes overlap one another as shown in the sample. This motion will release enough water to push the color to the sides. While you are painting the lead, rotate your board so that you are always painting toward yourself.

HOW TO PAINT LEAD

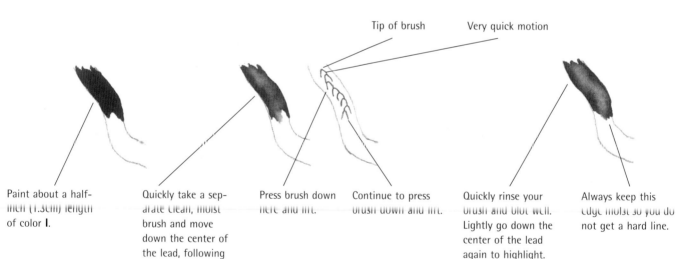

Tip of brush Very quick motion

Paint about a half-inch (1.3cm) length of color **I**.

Quickly take a separate clean, moist brush and move down the center of the lead, following the pattern of brushstrokes shown.

Press brush down here and lift.

Continue to press brush down and lift.

Quickly rinse your brush and blot well. Lightly go down the center of the lead again to highlight.

Always keep this edge moist so you do not get a hard line.

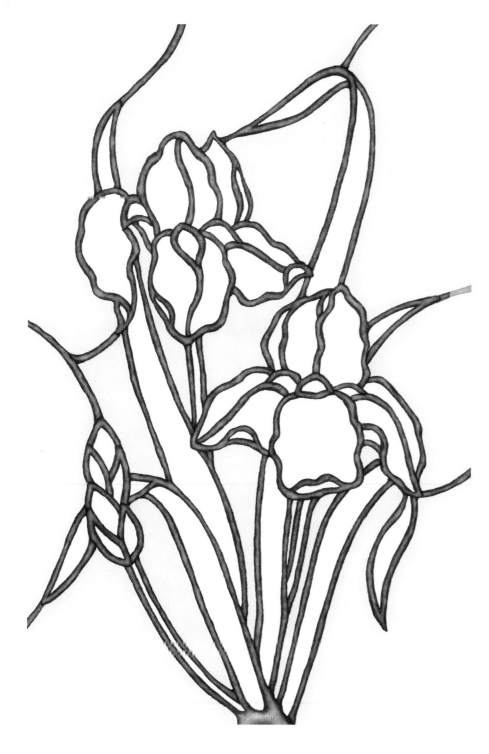

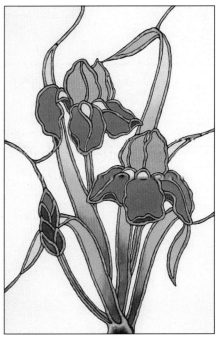

When you are finished with steps 6-8, your painting will look like this.

H I

CRITIQUING YOUR WORK

Now that you have completed all the steps, compare your painting and its values to the finished painting on the facing page. Look at your:

• Flowers. If the value of your petals is too light, paint over them again, but use a lighter value of the color. If your value is too dark, go over the entire section again, using clean water instead of paint. Apply pressure to the brush to move the pigment around on the paper as you go over the shape. When finished, lay a tissue over the petal shape and evenly blot up the excess color. Let dry. Then paint over the petal shape again with a lighter value.

If some of your petals appear blotchy or uneven, wet the area in the same manner as if you were painting with color. When you reach the area you would like to fix, gently tickle the area with your brush, moving around the color until you are pleased with the results, then finish painting the area with the water. Follow the same steps given for correcting the petals that got too dark. Let dry.

• Leaves. Follow the same guidelines given for the flowers. If one of the values on the charged leaves is too light, you can go back in and just darken the value that needs to be darkened without disturbing the value of the other color. For example, if your value for the dark green was too light, go back in as if you were painting the entire leaf again, except use clean water. Start at the top with the clean water. Gently move your brush just as you would if you were painting, being careful not to lift or disturb the color underneath.

When you reach the area that needs to be darkened, blot your brush, fully load it with a lighter value of the color, then charge the lighter color into the water. Finish painting the entire leaf. Let dry. This also works in reverse, starting with color and then switching over to clean water.

• Background. If your yellow appears too bright, or the values too dark, you can tone it down or lighten them by tickling over the areas with a clean, moist brush and then blotting with a tissue. If that does not work, then use a scrub brush and clean water.

• Lead. If all your color pushed to the edge, take a clean, moist brush and gently tickle along the darker color, and blot with a tissue. Let dry, then repaint that section.

If your lead got too dark and you do not have a highlight traveling down the center, just take a scrubber brush and, with clean water, lightly scrub down the center of the lead, then blot with a tissue.

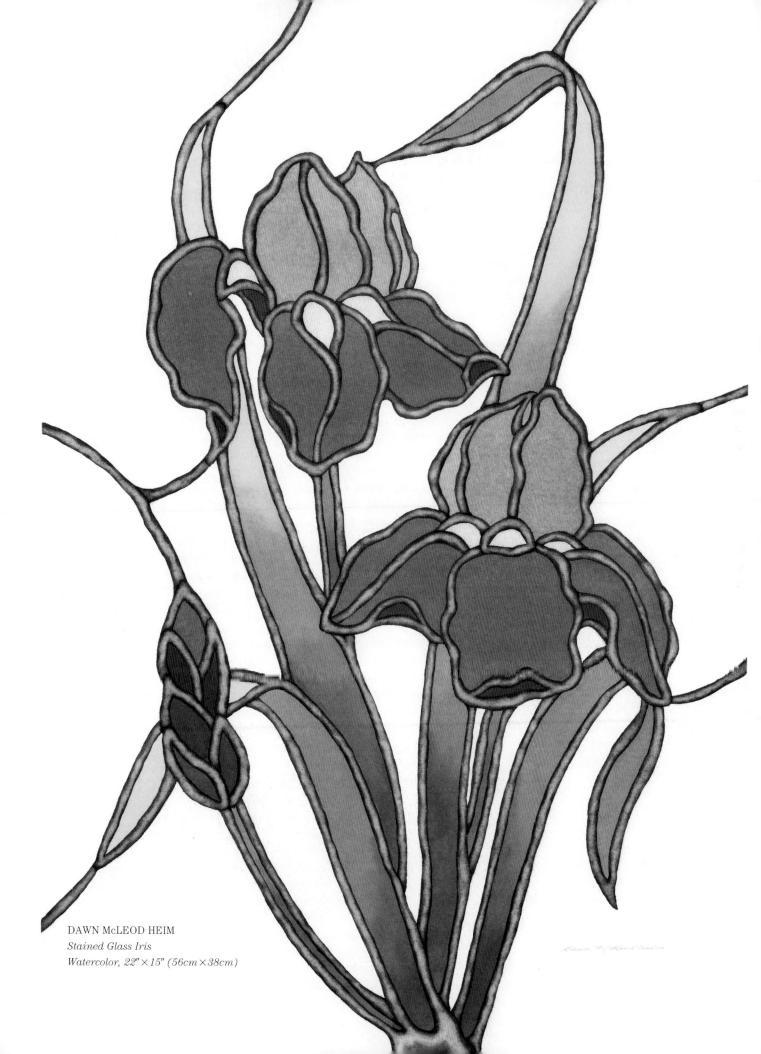

DAWN McLEOD HEIM
Stained Glass Iris
Watercolor, 22"×15" (56cm×38cm)

Painting a Wine Glass and Rose

DAWN McLEOD HEIM

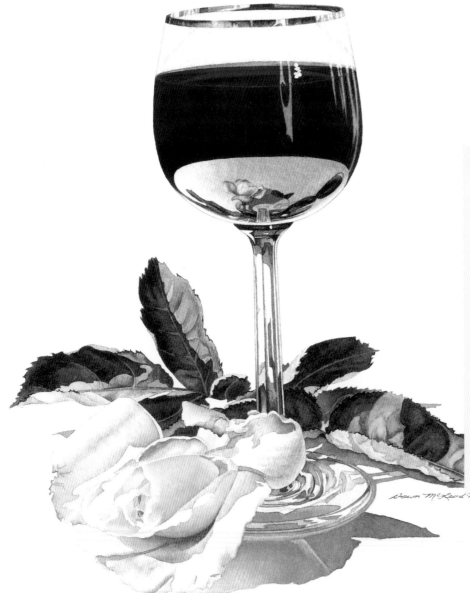

COLOR KEY

A New Gamboge
B Permanent Rose
C Sap Green
D Sap Green + Manganese Blue
E Permanent Rose + New
 Gamboge + French
 Ultramarine = taupe
F Raw Sienna
G Alizarin Crimson
H French Ultramarine
I Raw Sienna + Permanent Rose
J Sap Green + Winsor Blue + Alizarin
 Crimson = pine green (dark)
K Alizarin Crimson + Winsor Blue
L Raw Sienna + Burnt Sienna
M Sap Green + Winsor Blue + Alizarin
 Crimson = pine green (medium)
N Winsor Blue + Alizarin Crimson +
 Sap Green = brown/black
O Neutral Tint

In this demonstration, you will learn how to duplicate the look of glass by painting various reflective shapes of color and value. You will also learn how to paint a reflection mirrored against a dark and rounded object, as well as how to paint textured leaves and a light-colored rose with both warm and cool shadows.

MATERIALS

Winsor & Newton paints
- New Gamboge
- Permanent Rose
- French Ultramarine
- Raw Sienna
- Alizarin Crimson
- Winsor Blue
- Burnt Sienna
- Neutral Tint

Holbein paints
- Sap Green
- Manganese Blue

Brushes
- No. 6 round, with a nice point
- No. 8 round
- No. 10 round
- Scrubber brush

Other
- A quarter-sheet (15″×11″ or 38cm×28cm) Arches 300-lb. (640gsm), cold-press watercolor paper

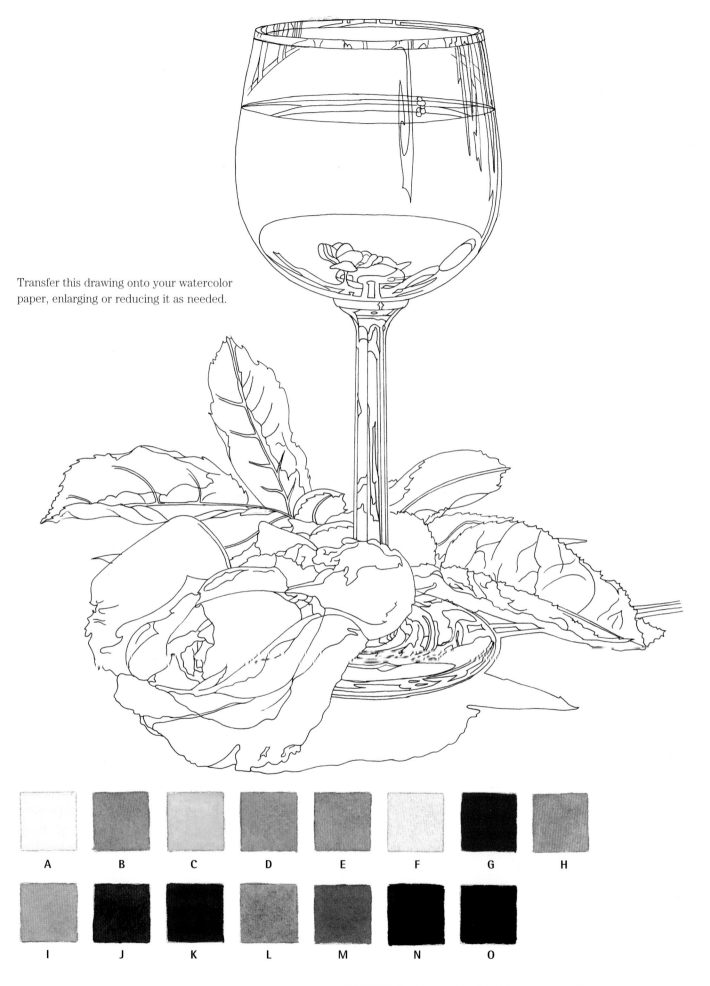

Transfer this drawing onto your watercolor paper, enlarging or reducing it as needed.

A B C D E F G H

I J K L M N O

UNDERPAINTING COLOR IN THE GLASS, ROSE PETALS AND LEAVES

1 PAINT ROSE PETALS

Remove most of the rose drawing on your watercolor paper with a kneaded eraser. Load your brush with **A** and paint all the yellow areas on the petals, softening some of the edges with water. Let each area dry completely before painting the one next to it. Load your brush with **B** and paint all the pink areas on the petals in the same manner.

2 PAINT LEAVES

Paint the underside of the leaves first, one at a time. Load your brush with **B** and paint along the leaves' outer edges. Quickly take a separate brush loaded with **C** and charge **C** into **B**. Finish painting the rest of the leaves with **C**. While your wash is still moist, take a tissue and lightly blot out a few highlights. Let dry.

Paint the tops of the leaves next, using alternating charges of colors **B**, **C** and **D** as shown in the sample. Let each leaf dry before painting the one next to it.

3 PAINT GLASS

Load your brush with **H** and paint all of the areas in the base and stem, softening some of the edges. Paint the rest of the areas in the stem with **B**, **C** and **D**, using a brush that has a nice point, and charging some of the colors as shown in the sample. Load your brush with **E** and paint all the areas in the base, softening some of the edges. Remember to let each area dry completely before painting the one next to it.

Take a brushload of **F** and make a new puddle, adding enough water to make a very light value. Load your brush with the lighter value and paint the area below the rim and above the wine line, being careful not to paint over the white highlights. Let dry. Paint the two areas with **F** as shown in the sample, then soften with water.

4 PAINT REFLECTION IN WINE GLASS

Load your brush with clean water, and wet the area located below the wine line and above the reflection line and to the left of the center highlight. Blot your brush well, then fully load it with **E**. When the sheen is almost gone, work quickly from the right side of the wine line to almost the bottom of the reflection and then work to the left side, allowing **E** to charge into the water.

After blotting your brush well, quickly dip it into **B**, and charge **B** into **E**. Paint a short distance to the left. Blot your brush again and quickly dip it into **A**, then charge **A** into **B**. Rinse your brush and blot well. Load your brush with **A** again and paint a short distance. Soften all along the lower edge with a clean, moist brush. Let dry.

5 PAINT WINE

Load your brush with **G** and paint the area shown in the wine, being careful not to paint over the white highlights. Let dry.

6 PAINT RIM

Load your brush with **F** and paint all the gold areas on the rim. Let dry. Load your brush with **G** and paint the red area on the rim. Let dry.

7 PAINT CAST SHADOW

Load your brush with **E** and paint the stem's cast shadow and the shadows under the leaves. Let dry.

Paint the large cast shadow from the rose next. Fully load your brush with **E** and, starting on the right, paint to the left with **E** as far as the sample shows you to. Then, load your brush with **B** and charge **B** into **E**. Paint a small area. Load your brush with **A** and charge **A** into **B**. Finish painting the rest of the shadow. While the wash is still damp, use a clean, moist brush to lift out a highlight and lift out along the front of the base as shown in the sample. Let dry.

TIP ADJUST VALUE EARLY

When painting over the center highlight and reflection in the wine, try to keep your value as close to the sample as possible. If it comes out too light, go over it again until it comes close to the value shown. If you try to adjust the value at the end of your painting, the Alizarin Crimson may bleed color into the reflection.

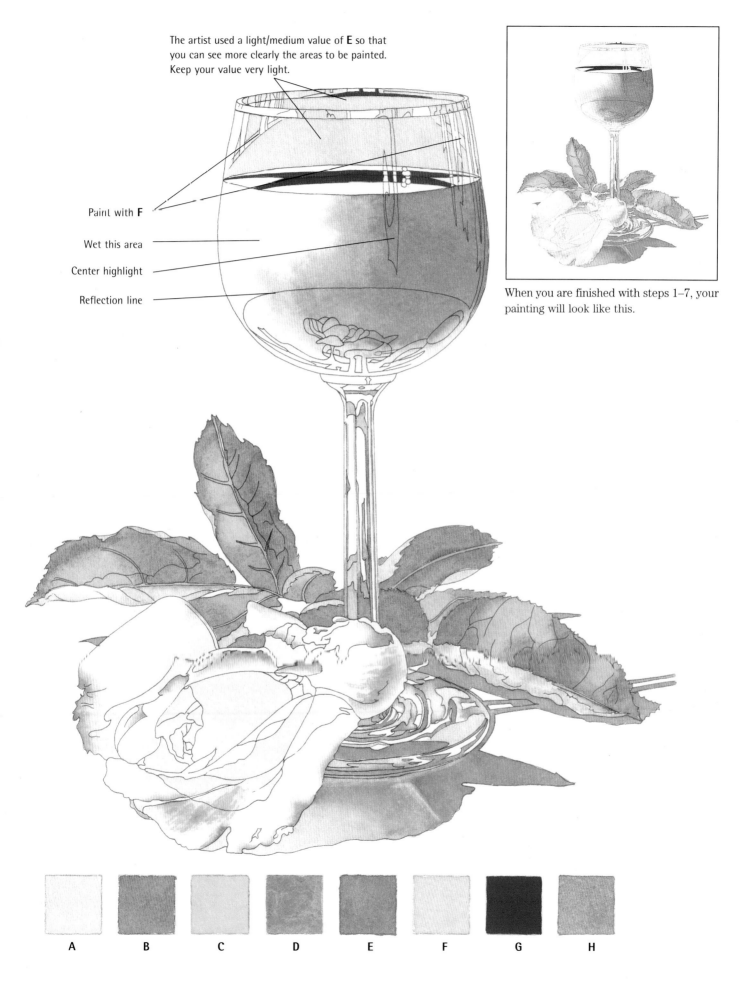

The artist used a light/medium value of **E** so that you can see more clearly the areas to be painted. Keep your value very light.

Paint with **F**

Wet this area

Center highlight

Reflection line

When you are finished with steps 1–7, your painting will look like this.

A B C D E F G H

ADDING MORE COLOR AND SHADOWS

8 PAINT WARM AND COOL SHADOWS IN PETALS

Load your brush with **I** and paint all the warm shadows in the center of the rose, charging in with **A**, and also with **B** on the two lower areas as shown in the sample. Let each section dry before painting the one next to it. Load your brush with **C** and paint those areas, softening the one edge with water. Next, make a small light/medium value puddle of **E**. Load your brush with the lighter value and paint all the cool shadow areas, softening some of the edges as shown. Let dry.

9 PAINT SHADOWS IN LEAVES

Load your brush with **J** and paint the large shadows in the leaves, charging in with **D** on the areas shown in the sample. Carefully go around the center and side vein lines, softening some of the areas with water. Paint the smaller shadows with **D** and **J**, softening the edges with water. Then, load your brush with **E** and paint the shadow areas on the undersides of the leaves, again softening the edges. Let dry.

10 PAINT MORE DETAIL IN GLASS

Load your brush with **E** and paint all those areas in the stem and the base, softening the edges with water. Let dry. Load your brush that has a nice point with **J** and paint along the lines and the small shapes in the stem and in the base, softening the one edge with water. Paint the **D** and **H** areas next, charging in with **E** as shown in the sample. Remember to let each area dry before painting the one next to it.

11 PAINT ROSE AND LIGHTER SHADOWS IN REFLECTION

With **A** and **B** paint the rose reflection in the wine glass, letting each petal dry before painting the one next to it. Load your brush that has a nice point with **E** and paint the large shadow shapes and along some of the lines as shown in the sample. Let dry.

12 PAINT UNDERLYING COLOR OF WINE

Load your brush with **I** and paint the area above the wine line, gently tickling along the red edge with your brush and allowing a little of the red color to bleed into **I**. Let dry. Fully load your brush with **K** and paint the area below the wine line, carefully going around the center and side highlights and the reflection. Let dry. With **K** still in your brush, paint the area above the wine line. Let dry.

13 PAINT MORE COLOR ON RIM

Load your brush that has a nice point with **L** and paint all the areas around the rim, softening some of the areas with water. Let dry.

14 DEEPEN CAST SHADOWS FROM ROSE AND LEAF

Load your brush with **J** and paint along the bottom of the large leaf on the right. Blot your brush well, then quickly load it with **E** and paint the rest of the leaf's cast shadow, charging **E** into **J**. Let dry.

Paint the large cast shadow from the rose next. Load your brush with **E**, and starting on the right, paint to the left with **E** as far as the sample shows you to. Quickly and gently charge the water from your brush into **E**, and finish painting the rest of the shadow with light brushstrokes and the water in your brush. When completely dry, take your scrubber brush and scrub out along the previous highlight and along the front of the base.

TIP KEEP SHADOW VALUES LIGHT

Keep your shadow values light on the rose, as shown in the sample. Remember: It is easier to go back in to darken the shadows than it is to lighten them.

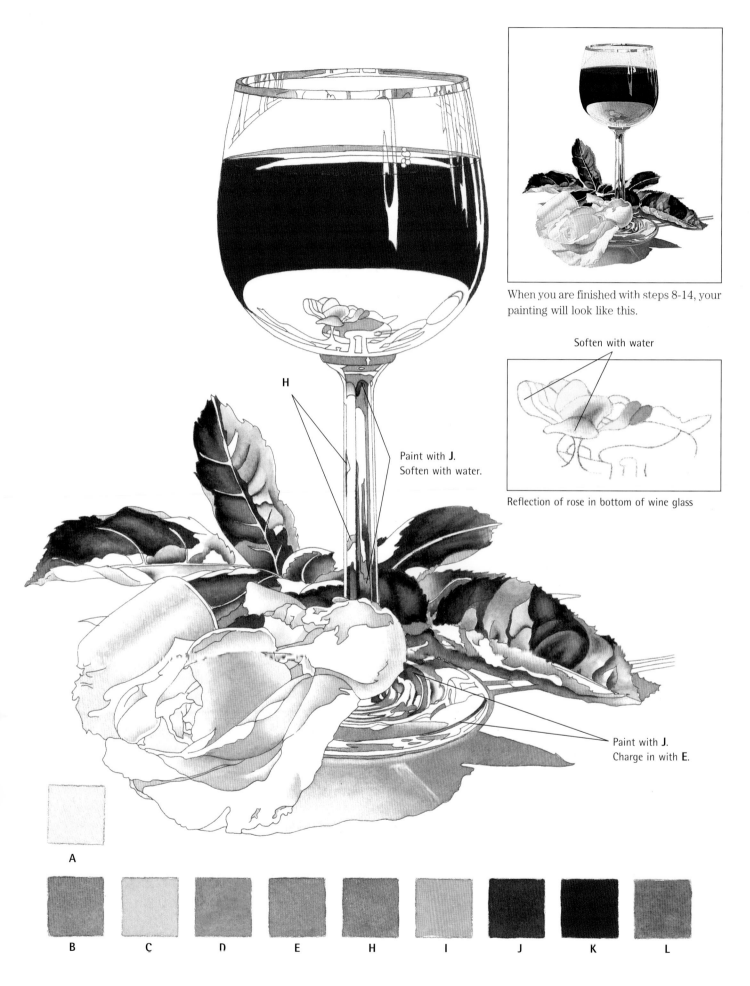

When you are finished with steps 8-14, your painting will look like this.

Soften with water

Reflection of rose in bottom of wine glass

H

Paint with **J**.
Soften with water.

Paint with **J**.
Charge in with **E**.

A

B C D E H I J K L

ADDING DETAIL AND COLOR TO THE GLASS, ROSE PETALS AND LEAVES

15 ADD MORE COLOR TO SHADOWS ON PETALS

Load your brush with **I** and paint all of those shadows, softening with water as shown in the sample. Then, load your brush with **L** and paint those areas, softening most of the edges with water. Let each area dry before painting the one next to it. Load your brush with **B** and paint those areas, charging in with **E** as shown. Let dry. Load your brush that has a nice point with **G** and paint along the edge that's curled under on the back petal, softening upward with water. Let dry.

16 GLAZE AND OUTLINE LEAVES

Load your brush with **M** and glaze over each dark shadow in the leaves, including over the center and side veins. Let dry. Load your brush that has a nice point with **G** and outline the outer edges and the center vein line shown in the sample. Let dry.

17 PAINT FINAL SHADOWS IN STEM

Paint the areas at the top of the stem with **L** and **N**, softening the edges and lifting out a highlight as shown in the sample.

18 PAINT DARKER SHADOWS IN REFLECTION

Paint the shadows in the rose reflection with **B**, **E** and **L**, softening some of the edges with water. Let each area dry competely before painting the one next to it. Load your brush with **E** and deepen the value of the glass shadows you painted previously. Load your brush with **J** and paint the reflection of the leaves, charging in **N** as shown in the sample. Let dry. Load your brush with **N** and paint all the dark shadows. Let dry.

19 PAINT FINAL COLOR OF WINE

Fully load your brush with **O**. Starting slightly below the original wine line, paint over all the red areas, carefully going around the reflection and the center and side highlights. Let dry. Paint the areas above the wine line as shown in the sample. Let dry.

20 PAINT SHADOW SHAPES ON RIM

Load your brush that has a nice point with **M** and paint those areas along the front of the rim, softening with water. Let dry. Load your brush with **N** and paint the rest of the dark shapes, charging in with **L**, and softening some of the edges with water.

21 ADD FINISHING TOUCHES

Take a clean, moist brush and gently tickle some of the surrounding color over the white highlights in the wine area. With the same clean, moist brush, make a chisel edge, and lift out some of the color below and along the line that shows the wine level. Erase the pencil lines from the highlights.

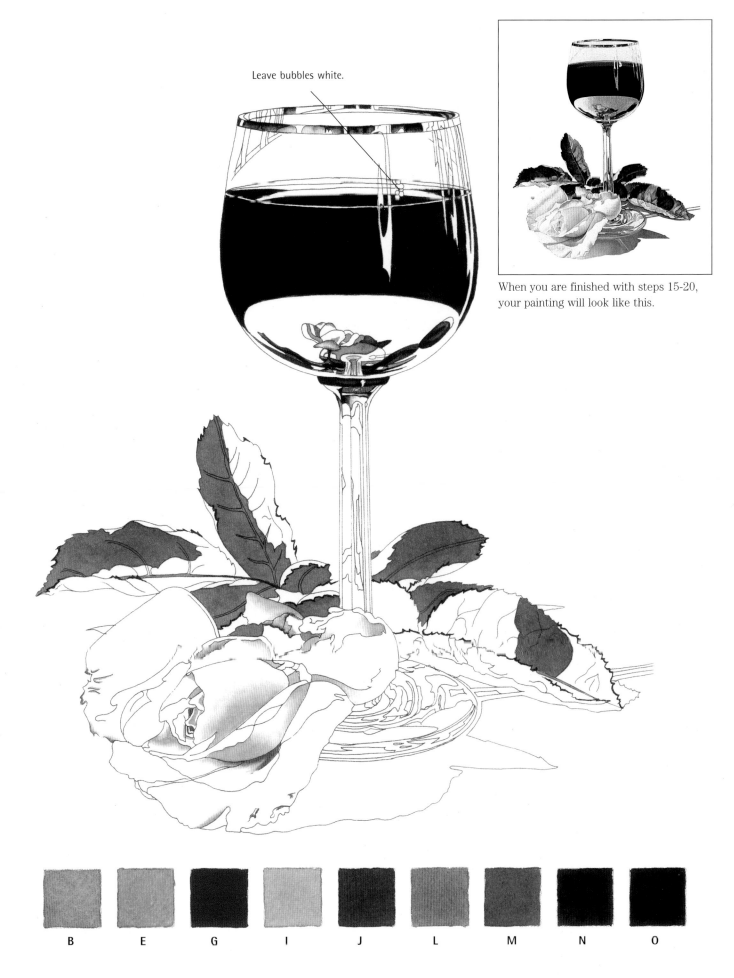

Leave bubbles white.

When you are finished with steps 15-20, your painting will look like this.

B E G I J L M N O

CRITIQUING YOUR WORK

Now that you have finished all the steps, compare your painting and its values to the finished project on the facing page. Look at your:

• Rose petals. If your values for the yellow areas around the center are too dark, try lifting some of the color first with a clean, moist brush. If that doesn't work, try gently scrubbing out some of the color with your scrubber brush. Let dry, then glaze with New Gamboge.

If your shadows got too dark, take a clean, moist brush and gently lift some of the color, then blot with a tissue. Let dry. If you lost your pink color, go back in and paint those areas again.

• Leaves. If the undersides of the leaves are too dark, take your scrubber brush and gently scrub some highlights into the leaves, and blot. If there is not enough difference between the value of the leaves and the shadow areas on them, go back in and darken just the shadow areas.

• Glass. There should be both light and dark values in the stem and the base. If there aren't, go back in and deepen some of the values, and possibly lighten some.

• Reflection of the rose. Is there enough variation of color between the petals? If not, darken the shadow areas, or add more color. Do the same for the leaves and the base.

• Wine. If the value of the wine is too light, go back in and darken it with a lighter value of **O**. If the value is too dark or has a pigment sheen to it, it's best to leave it alone. Once your painting is matted and framed, you won't be able to see it.

• Gold rim. If your rim lost its circular design, load your brush with the color of the shape you want to straighten. Then blot your brush on a tissue, and lightly smooth out your jagged or crooked edge. If you lost your lights, take a tiny bit of an acrylic white paint and paint the areas that need to be lightened.

• Cast shadow. If your cast shadow from the rose got too dark, just leave it as is. Instead of trying to make it lighter, try to offset the darker value by adding darker values in the base, stem and the shadows under the leaves.

If your shadow appears blotchy, load your brush with water. Starting at the back, paint the shadow areas again, lightly tickling over the blotchy areas. Finish painting the shadow with the watercolor in your brush. If your shadow by the rose got too dark, take a clean, moist brush and lift out some of the color, but do not blot.

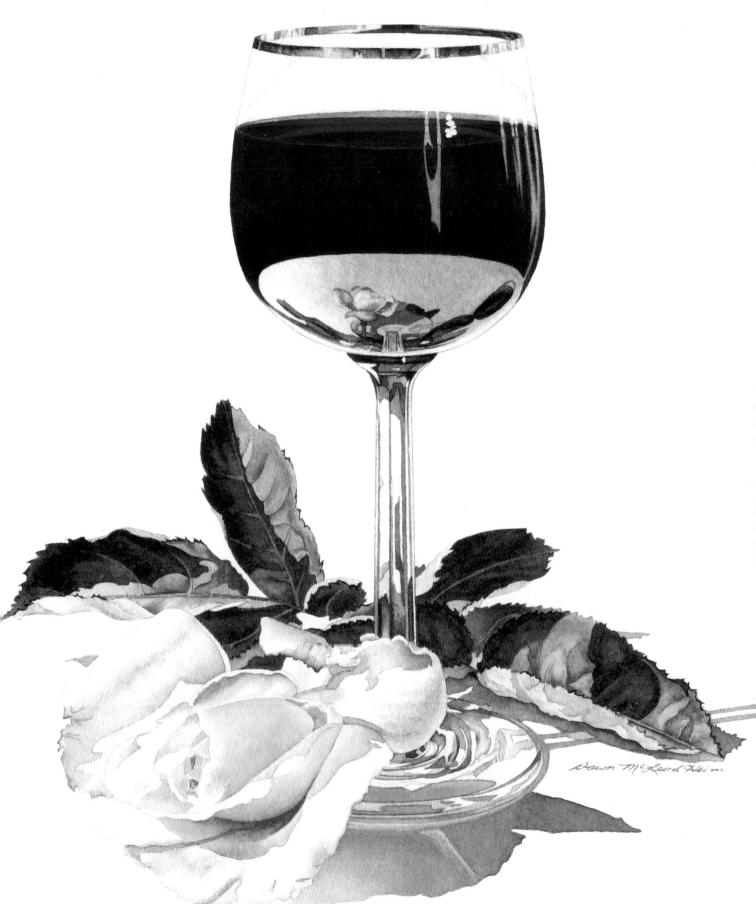

DAWN McLEOD HEIM
Wine Glass and Rose
Watercolor, 15"×11" (38cm×28cm)

Glass in Mixed Media

C L A U D I A N I C E

1 Apply a pale, preliminary wash to establish the basic shape and highlights.

2 Add inner contours while maintaining light reflection areas.

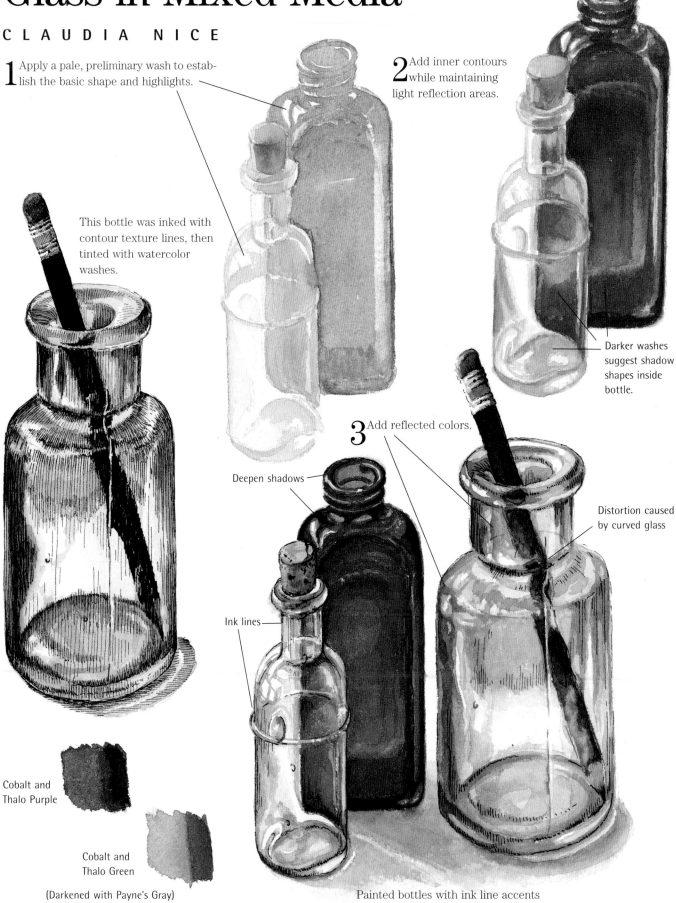

This bottle was inked with contour texture lines, then tinted with watercolor washes.

Darker washes suggest shadow shapes inside bottle.

3 Add reflected colors.

Deepen shadows

Ink lines

Distortion caused by curved glass

Cobalt and Thalo Purple

Cobalt and Thalo Green

(Darkened with Payne's Gray)

Painted bottles with ink line accents

Contour ink lines for definition

Liquid frisket was used to protect white highlights during paint application.

Highlights reflected from flame

Objects behind glass often appear distorted.

Stippled ink texturing

Reflected color

Amber-colored lamp oil

Lighter colors represent the illumination of light filtering through the lamp.

As clear antique glass ages it often takes on an amethyst tint.

Cut Crystal

Faceted surfaces reflect multiple highlights, shadows and reflected color. Simplify this "light play" where possible and maintain plenty of sparkling white highlights. (The pepper in the shaker was textured with ink scribble marks and dots.)

Antique Glass

This antique lamp was painted with layers of watercolor washes, and then a few well-placed ink texturing strokes were added.

Rose Madder and Payne's Gray

When pen-and-ink detail work is used to accent only the rough-surfaced objects within the composition, contrast of texture is greatly increased.

Compare the rough texture of the inked and painted rope to the smooth look of the glass to which no pen work was added.

Note how the objects seen through glass are distorted both in coloration and shape.

The sand was the first area of the composition to be painted, using a light wash overlaid with spatter. The adjoining areas were protected with liquid frisket.

The rope and entangled sea life were detailed with pen and ink, then tinted with watercolor.

These Japanese floats were painted with layered washes of watercolor, blended one into another using damp surface and wet-into-wet techniques. Begin with the light green washes working toward the deeper shadow tones.

Beads and marbles make fun miniature glass study projects. Note the differences in the opacity of the marbles.

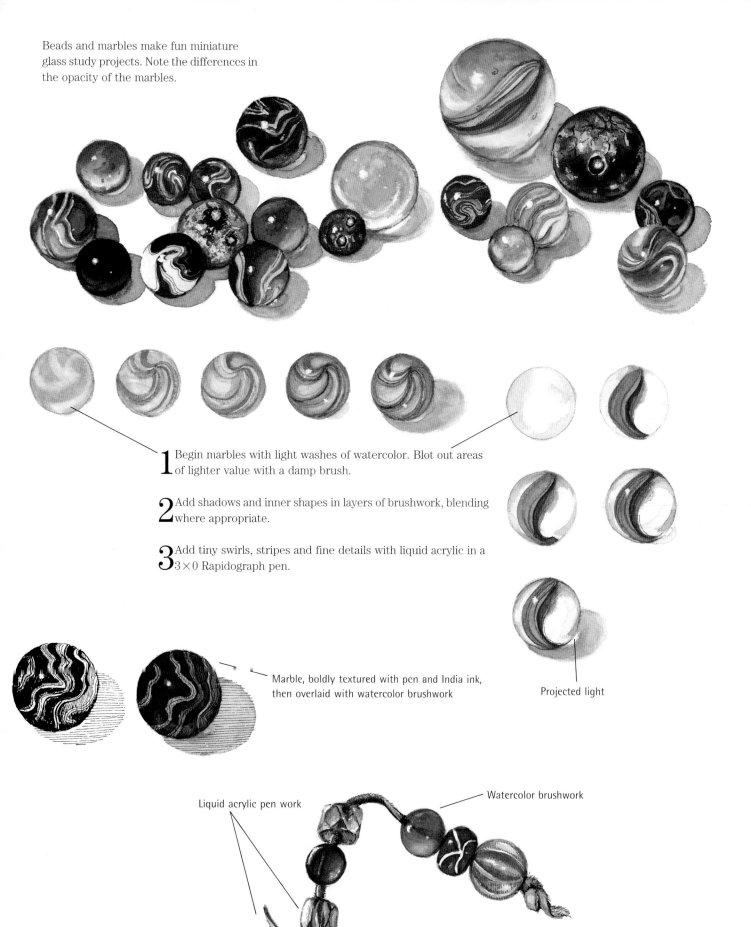

1 Begin marbles with light washes of watercolor. Blot out areas of lighter value with a damp brush.

2 Add shadows and inner shapes in layers of brushwork, blending where appropriate.

3 Add tiny swirls, stripes and fine details with liquid acrylic in a 3×0 Rapidograph pen.

Marble, boldly textured with pen and India ink, then overlaid with watercolor brushwork

Projected light

Liquid acrylic pen work

Watercolor brushwork

Painting Elegant Textures: China, Lace and Silver

Painting China

ARLETA PECH

A still-life painting that includes china presents new challenges for the watercolor painter. The reflective surface of china adds interest to your painting's visual impact. Highlights and values are what make the reflective surfaces shine. Let's compare how to make two very different-looking pieces of china shine—a dark china pitcher and a light creamer.

1 Use Burnt Sienna, Permanent Rose, New Gamboge and Cobalt Blue for a thin mixture of soft cream color for the first glaze. Work from the deeper color on the right side, and soften the value near the white highlight area on the left side of the creamer.

COMPARISON
In the first glaze both pieces are painted a similar value. What's important is to save the highlights and begin to shape the china's form.

1 Paint the first glaze with Hooker's Green Dark, Antwerp Blue and New Gamboge. Use Permanent Rose to show the bounced color from the roses. Work around the hard-edged white highlights, alternating colors. Leave a lighter Antwerp Blue where you want a light value. The form of the pitcher is developed by where the deeper color begins and ends. Paint around the highlights.

2 Remove the pencil lines when the first glaze is dry and apply a second glaze of the same color values to deepen the color glaze. Work from dark to light. Each highlight on the china is important. At this point the highlights are white, but as the glazing process continues some will receive a colored glaze to show a variety of highlight values, adding interest and bounced color from reflected objects.

Pay attention to the form of the pitcher when painting the second glaze. Notice the deeper color at the base of the neck. Pulling the paint keeps the round section a lighter value to enhance the shape. To create depth in the saucer, keep the color deeper at the bottom and soften to a lighter value toward the top.

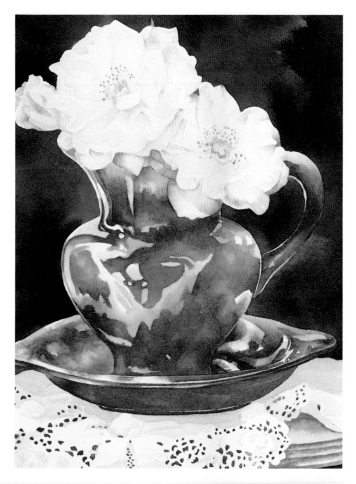

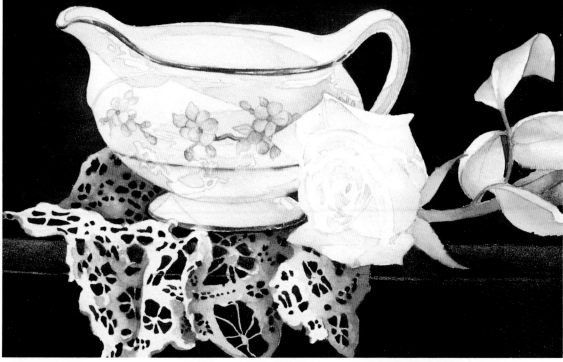

PALETTE
- Hooker's Green Dark
- Antwerp Blue
- New Gamboge
- Permanent Rose
- Burnt Sienna
- Cobalt Blue
- Cadmium Orange
- Alizarin Crimson

2 Keep the pencil lines in order to paint the flower pattern on this light creamer. Use a mixture of Permanent Rose, Burnt Sienna and Cobalt Blue for the flowers and a deeper, browner mixture of the same colors for the stems. The leaves are Cobalt Blue and New Gamboge. Paint the gold rim with Burnt Sienna and a touch of Cadmium Orange. Remove the pencil lines after the pattern has dried.

3 The third glaze is again the same color mixtures, but deeper in value. Be careful not to get the value too intense, though. Remember when glazing you're working on top of color, so it doesn't take a big value leap to deepen the color. Apply this glaze from the sides of the pitcher and lighten toward the middle. At this point take a look at the highlights and tone down certain ones so there are a variety of values in the highlights. Notice a touch of Permanent Rose in the highlight at the handle's inner edge and in several highlights where the flower color is bounced onto the pitcher.

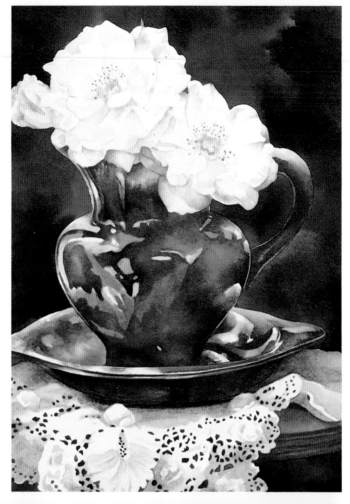

3 Now that the pencil lines are erased, we can see the soft transition of color. We just need to deepen the value to the left of the creamer and from the bottom to the top, creating a round look with the glazes.

4 Apply the final glaze, paying close attention to the areas of strong contrasts, such as next to the lightest highlight on the left side. Add a touch of deep color here to make it "pop." Add a glaze of Antwerp Blue to the highlights that need toning, such as the top of the handle. If you need to adjust values in the pitcher, make sure the saucer also has the correct value showing the bounced highlights. The finished piece has the sparkle of a reflective surface and three-dimensional roundness.

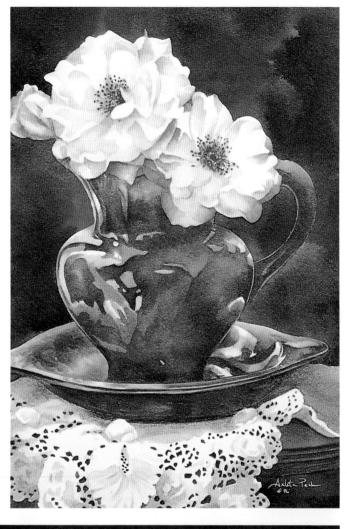

below

4 Use mixtures of Alizarin Crimson and Hooker's Green Dark for the final glazes on the creamer in order to pull the background colors into the soft color of the creamer. This enhances the roundness and also helps to emphasize the highlights on the right side. Notice the soft value of the flower pattern on the left side. Keeping a lighter value on this enhances the feeling of a sunlit edge and helps give the visual clue of the shape of the creamer.

COMPARISON
Each piece of china was painted with the same process of glazing; the difference was the depth of color. Each piece retained its highlights, and the glazes enhanced the roundness by applying color from the deepest area and softening the value out to the lightest area.

Painting Lace

ARLETA PECH

When working with fabric—and lace is just fabric with a lot of holes—you must establish the form in your drawing and create the rolls and folds with your first glazes of color. The angles of the holes and values help to define the form of the fabric.

PALETTE
- Winsor Violet
- Burnt Sienna
- Cobalt Blue

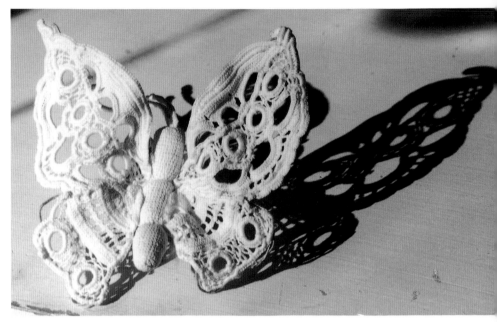

Reference
In this photo there's a strong cast shadow that creates negative holes. Another important observation is the light-value holes on the left side and where they change to the deep cast shadow on the right. This gives the lace butterfly interesting values to work with.

1 Draw the design with all the holes, even in the cast shadow. Be sure to draw the shadows, too; they help to define the shape of the butterfly. Since the cast shadow provides the only contrast, use a light glaze of Winsor Violet to paint the background—including the area of the cast shadow, so the holes in the cast shadow will be the background value. Allow this to dry, and paint the shadow areas on the butterfly using Winsor Violet and Burnt Sienna. Soften edges so not all the shapes are hard-edged.

2 Paint the cast shadow with Winsor Violet and Cobalt Blue, working around each negative hole shape. You can use frisket if the negative holes are too numerous to work around, but the frisket will leave a harder look to the edges of the holes. Once this dries, use the same value and color of Winsor Violet and Cobalt Blue to paint the deep-value holes on the butterfly. Use the background value and color for the light-value holes. When dry, remove the pencil lines.

3 Enhance the area of shadows on the butterfly with a deeper value of Winsor Violet and Burnt Sienna, allowing edges of the holes to soften. Deepen the cast shadow, and use Burnt Sienna to warm the cast shadow closer to the butterfly. Adjust the deep-value holes in the butterfly according to the hue of the final cast shadow.

Painting White Lace on White

ARLETA PECH

Here's a more extensive lace demonstration. It's really the same as the lace butterfly on the previous pages, only more of it.

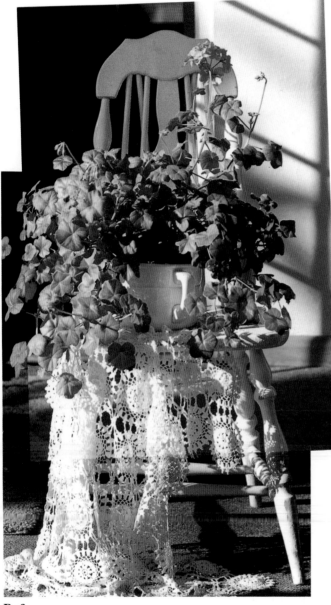

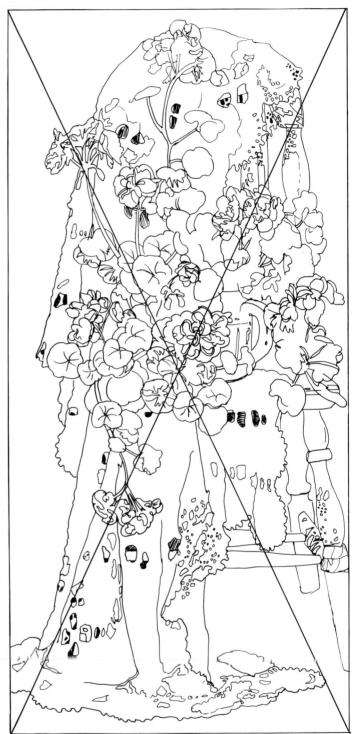

References

This is a composite of two photos, though more were used. The artist set this old Windsor chair, draped in lace with a geranium plant on its seat, in a strong shaft of sunlight. As blooms appeared, she redraped the top of the chair until she got an exciting cast shadow with the lace.

Rough Drawing With Placement ×

Place blooms so they guide the eye through the painting. Make a rough drawing of the chair and then draw an × on the paper. Using the × as a guide, add the blossoms along the × in different areas and the lace folds.

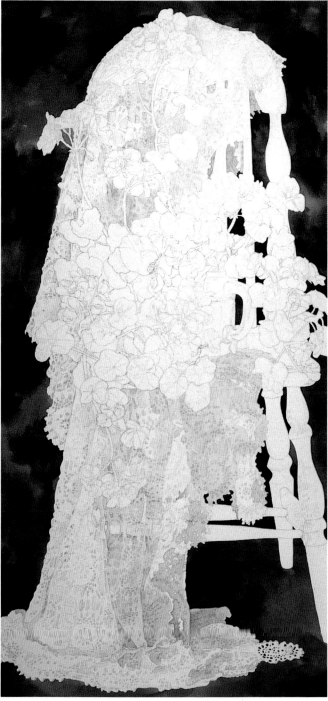

1 DRAW AND GLAZE

Fine-tune the drawing when transferring it to watercolor paper. It's critical to show where the highlights are in your drawing so they can be left white. Draw all the details of the lace holes, with particular attention to the chair behind the lace. Draw the blossoms and leaves, paying particular attention to where you place the highlights and cast shadows.

Use Hooker's Green Dark, Antwerp Blue, Winsor Violet, Burnt Sienna and Cobalt Blue for the background. Then, apply the first glaze to the lace folds, using Cobalt Blue and Burnt Sienna. Work from the deepest folds out.

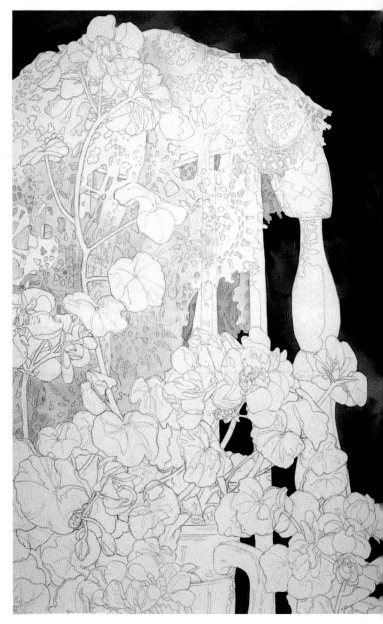

DETAIL In this detail of the upper area of the lace, notice the deeper glaze on the underside of the lace that's behind the chair back. Pay close attention as the layers of lace develop. Each layer of the lace and chair will have its own value.

2 PAINT LACE

Use Hooker's Green Dark mixed with Antwerp Blue to paint the dark lace holes. Not all holes will be the same color or value. The light-colored holes that show the chair underneath and the folds of lace are made with Cobalt Blue and Burnt Sienna for a soft blue-gray.

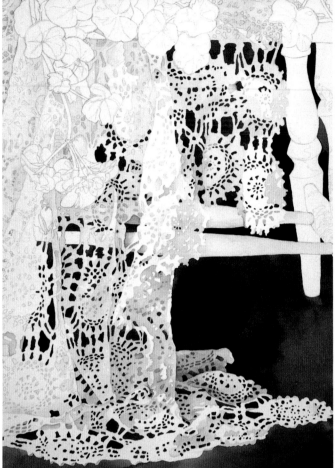

DETAIL OF LACE HOLES

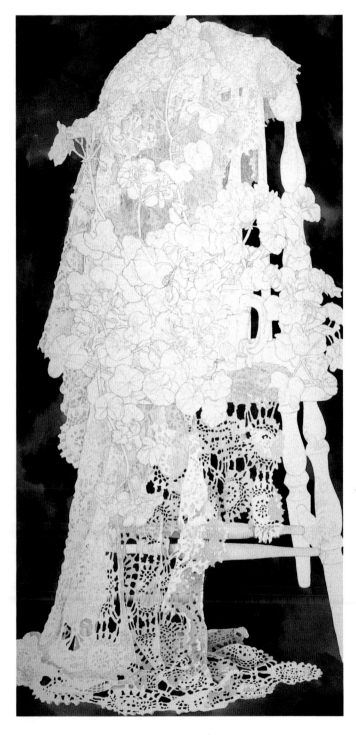

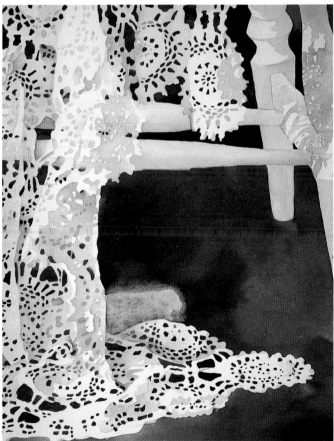

right

The piece of lace lying on the floor didn't seem right, so the artist decided to remove it. She scrubbed the edge of the dark background, mixed more background color and repainted the area.

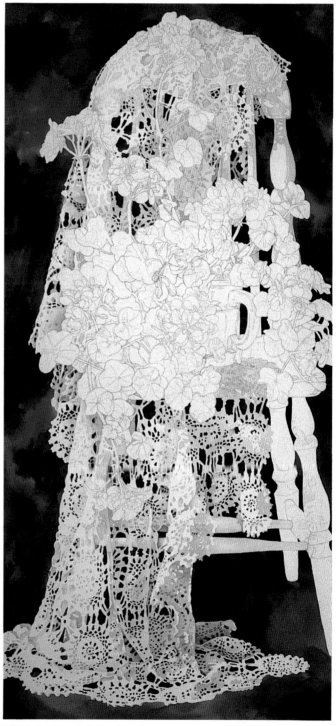

DETAIL This detail shows different values of holes and even a few bounced-light lace holes on the chair leg. Paint the shadow area around the small, light lace holes. Don't overdo this type of thing, but a few here and there add interest.

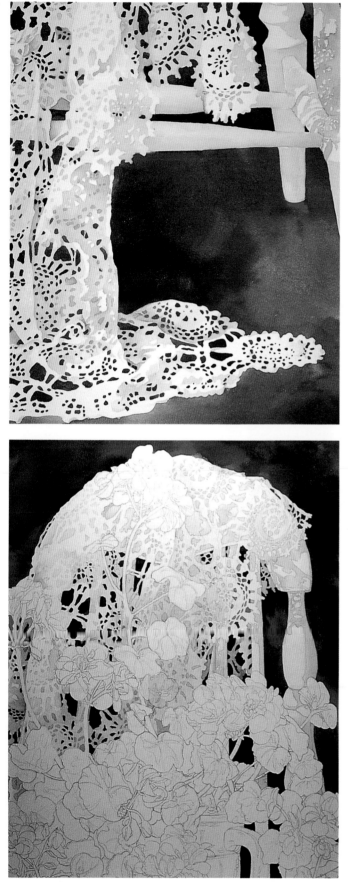

DETAIL Notice where the chair shows through the lace holes. This is a clue to the chair shape, even though it's not entirely visible.

All of the lace holes painted.

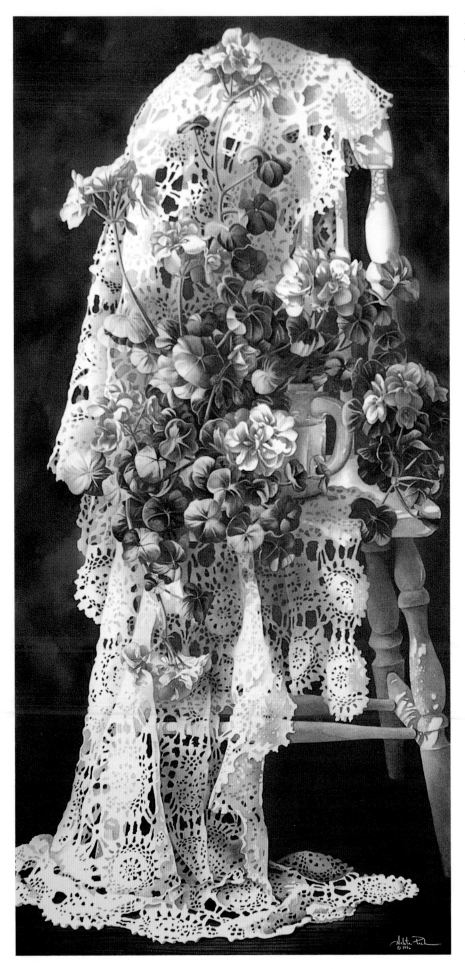

ARLETA PECH
Rhapsody in White
Watercolor, 43" × 22" (109cm × 56cm)
Private collection

Painting Lace With Other Textures

PENNY SAVILLE FREGEAU

Painting the various objects in this still life—an etched crystal vase and perfume bottle, a lace doily, a wooden mantel clock—presents a challenge to create several different textures.

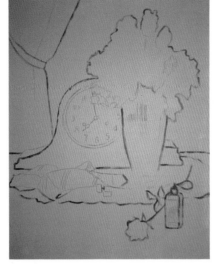

1 To nail down the composition, Fregeau starts with some preliminary sketches. After she is confident about the overall look, she enlarges the drawing, paying little attention to details to leave room for spontaneity.

2 Fregeau rapidly blocks in her darkest darks and lightest lights. At this stage, she wants to be sure the painting will catch the eye by means of contrast and drama.

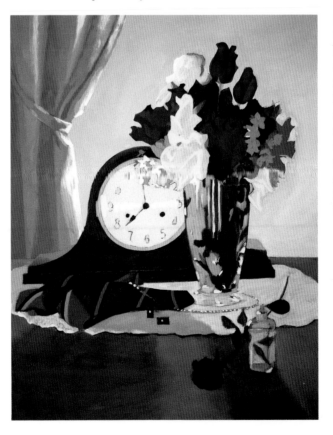

3 Now Fregeau starts blocking in local color—the actual colors of the objects in natural light. With the local and middle values established, Fregeau now has a better idea of the composition and color harmony. She begins to add some "color fullness" to the blocked-in colors.

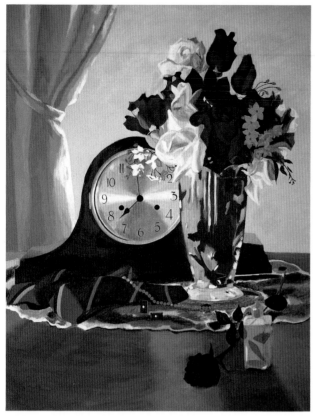

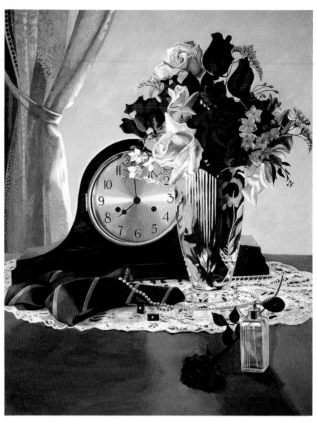

4 Dissatisfied with the angle of the clock, Fregeau brings the bottom left corner down behind the tie. "Since I have painted in a smooth manner," she says, "covering up the discrepancy is not a problem, as acrylics can be used in an opaque state." Painting thinly with a swirling motion, she applies more details and gives the sky a wash that lends it a more "atmospheric look."

5 Now Fregeau paints in the details of the doily with a small brush and turns her attention to the perfume bottle. To make the edges of the crystal and the etched portions of the vase look convincing, she uses a brush with worn-down bristles that come to a chiseled, pencil-type point to soften the edge of the paint.

6 At this point, Fregeau feels something more needs to be added to the composition, so she adds a pair of soft white gloves. When the gloves are blocked on to the painting, she also changes the center of interest by adding a table edge. More detail is added to the crystal.

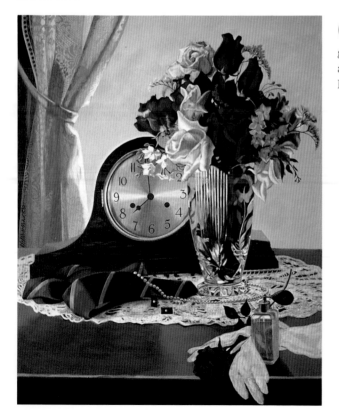

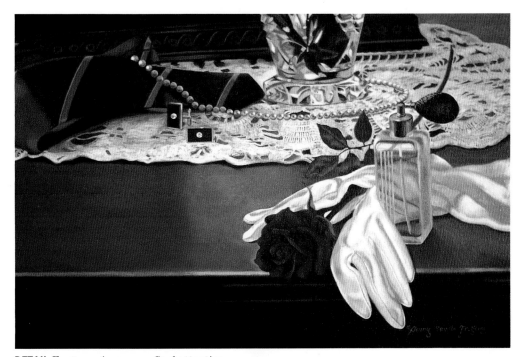

DETAIL Fregeau gives some final attention to the gloves as well as to the cuff links. "All the details in the painting are added to and scrutinized," she says.

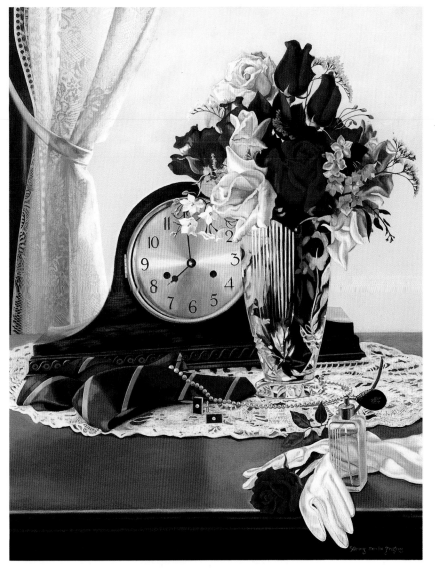

PENNY SAVILLE FREGEAU
When a Man Loves a Woman
Acrylic, 26"×20" (66cm×51cm)

Polished Silver in Mixed Media

CLAUDIA NICE

Silver is very pale in local color with strong highlights and a profuse display of reflected hues.

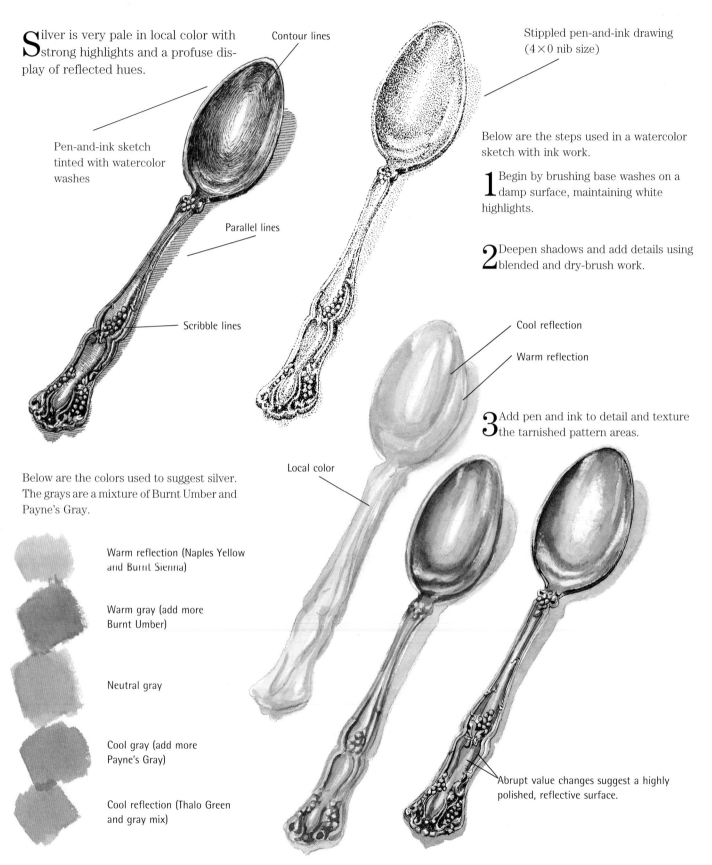

Contour lines

Pen-and-ink sketch tinted with watercolor washes

Parallel lines

Scribble lines

Stippled pen-and-ink drawing (4×0 nib size)

Below are the steps used in a watercolor sketch with ink work.

1 Begin by brushing base washes on a damp surface, maintaining white highlights.

2 Deepen shadows and add details using blended and dry-brush work.

Cool reflection

Warm reflection

3 Add pen and ink to detail and texture the tarnished pattern areas.

Local color

Below are the colors used to suggest silver. The grays are a mixture of Burnt Umber and Payne's Gray.

Warm reflection (Naples Yellow and Burnt Sienna)

Warm gray (add more Burnt Umber)

Neutral gray

Cool gray (add more Payne's Gray)

Cool reflection (Thalo Green and gray mix)

Abrupt value changes suggest a highly polished, reflective surface.

Brass, Gold, Copper and Bronze in Mixed Media

CLAUDIA NICE

These warm-hued metals are strong in local color. The light sienna tones are contrasted with dark, unblended streaks of rich brown, suggesting a reflective, shiny surface.

 Raw Sienna makes a good base color for brass, which consists of copper and zinc.

 Bronze, made up of copper and tin, can be represented with Raw Sienna/Burnt Sienna mixes.

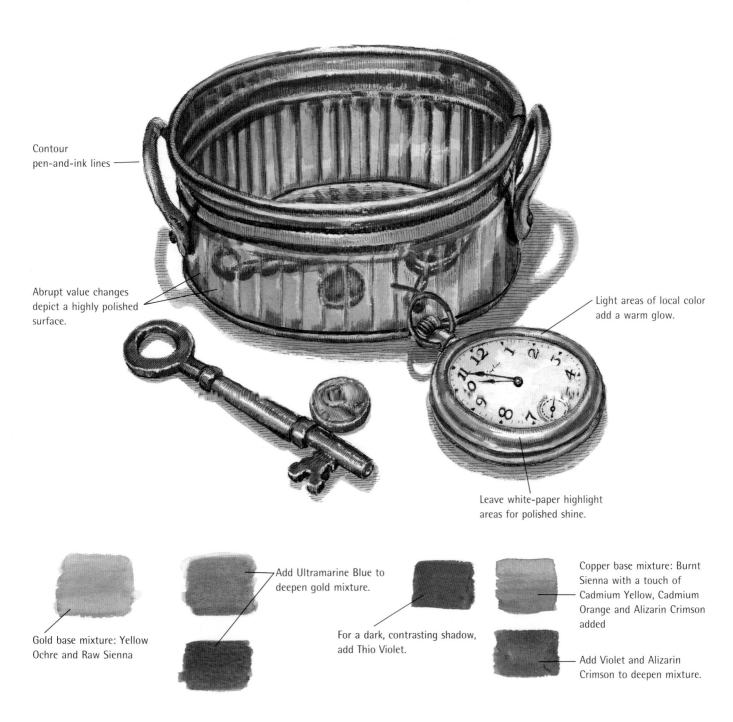

Contour pen-and-ink lines

Abrupt value changes depict a highly polished surface.

Light areas of local color add a warm glow.

Leave white-paper highlight areas for polished shine.

Gold base mixture: Yellow Ochre and Raw Sienna

Add Ultramarine Blue to deepen gold mixture.

For a dark, contrasting shadow, add Thio Violet.

Copper base mixture: Burnt Sienna with a touch of Cadmium Yellow, Cadmium Orange and Alizarin Crimson added

Add Violet and Alizarin Crimson to deepen mixture.

Painting Wood Grain and Painted Wood

Wood Grain in Mixed Media

CLAUDIA NICE

Continuous or broken wavy-line pen strokes are ideal for depicting the grain patterns of cut wood. The design patterns depend upon the wood type and how the wood was cut.

Rough Wood
Use a larger size nib and sketchy strokes.

Smooth Wood
Use a fine nib (4×0 or 3×0) and precise, flowing pen strokes.

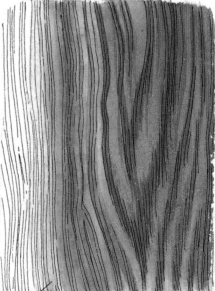

India ink tinted with watercolor

Walnut Wood

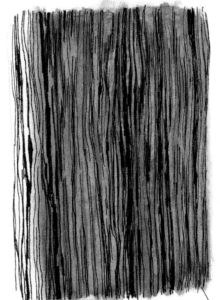

2 Apply dry fan brushwork.

3 Lay on additional washes and blend with a clean, damp brush.

1 Begin with a damp surface wash.

4 Add wood-grain texture lines using pen and ink.

Crosscut

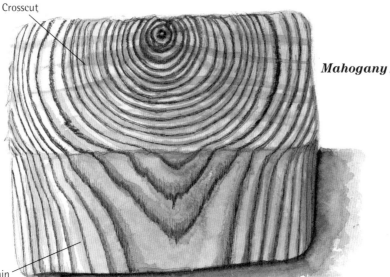

This block of hemlock wood was textured with brown pen work and overlaid with watercolor.

Cut with the grain

Mahogany

Bird's-Eye Maple

Maple

The mahogany and oak wood grains were penned with India ink, while brown liquid acrylic was used to texture the lighter woods. Watercolor washes may be added before or after the pen work.

Oak A fan brush was used here for additional texture.

Watercolor spatter

The pen work in the maple and cedar sketches was stroked promptly with a damp brush to blend and soften their appearance.

Distressed Ash Wood

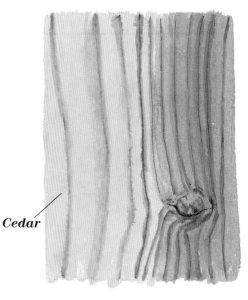

Cedar

Bruising is an additional method of creating a realistic wood grain appearance.

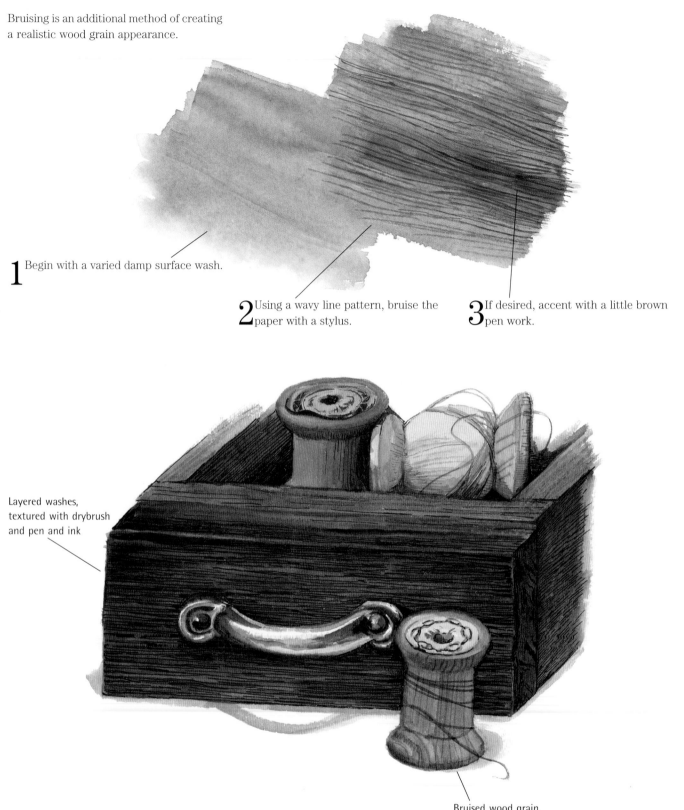

1 Begin with a varied damp surface wash.

2 Using a wavy line pattern, bruise the paper with a stylus.

3 If desired, accent with a little brown pen work.

Layered washes, textured with drybrush and pen and ink

Bruised wood grain, created with stylus

Polished Wood in Mixed Media

CLAUDIA NICE

Like shiny metal, polished wood has strong value patterns and lots of reflective color.

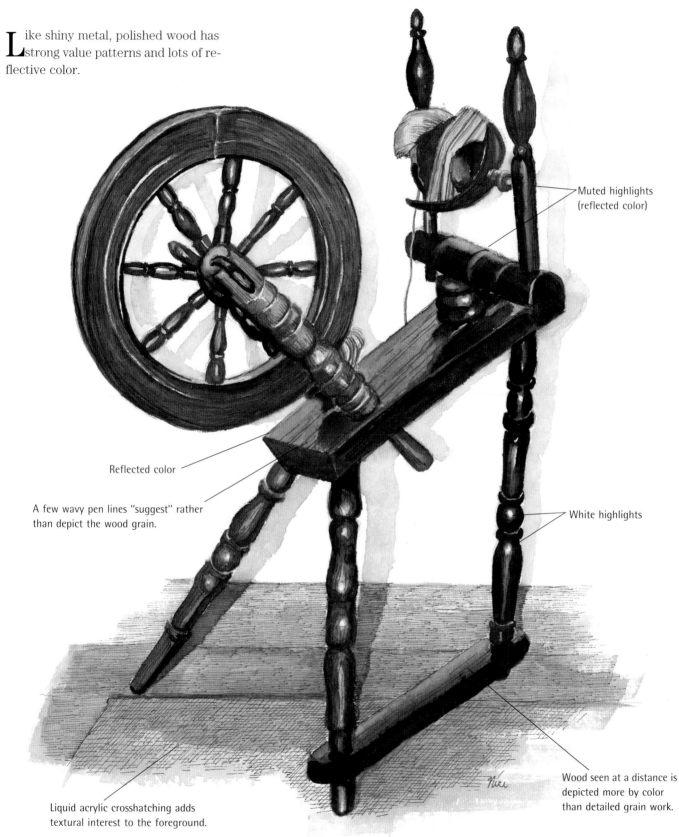

Muted highlights (reflected color)

Reflected color

A few wavy pen lines "suggest" rather than depict the wood grain.

White highlights

Liquid acrylic crosshatching adds textural interest to the foreground.

Wood seen at a distance is depicted more by color than detailed grain work.

Painting a Jug and Rocker

MICHAEL P. ROCCO

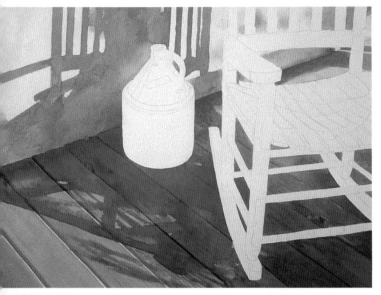

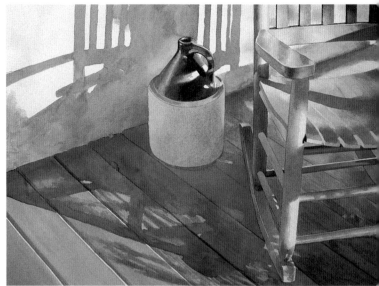

1 Give the entire sheet a wash of pale Yellow Ochre, then paint a basic light color to the porch floor, even in the shadow area. Your brushstrokes should follow the diagonal direction of the boards.

Mix an ample amount of color to paint the rhythmic shadows from the chair on the wall in one effort, keeping the color flowing. Use the same procedure on the floor, except here, variations of color occur within the shadow.

After this dries, go back over the boards individually with color slightly deeper than the original, leaving the edges highlighted to give them dimension. Put the leaf in for color.

2 Paint the light tone of the rocker's backrest, and while still damp, blend in its soft shadows. Then move to the seat and follow the same procedure. Painting in small areas enables you to take advantage of the dampness of the paper.

Handle the base of the jug with a wet blending of color to achieve its roundness. But on the dark upper portion, paint definitive color areas, which can be blended later.

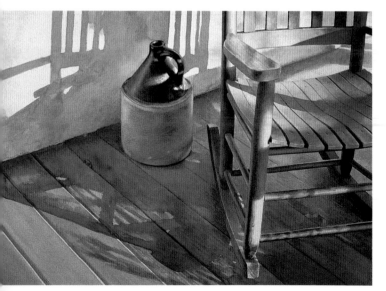

3 Now go over the entire chair, gradually deepening shadows, forming the turned legs and rungs, being aware of the reflected light that adds to their roundness. Blend darker color on the seat, accenting its compound curves, and finish with the lines dividing the slats.

Noodle the base of the jug with progressively deeper values of color, working in from both sides, with the deepest tones toward its center. Blend intermediate colors in the upper section, working it into the look of a smooth, glossy surface. Wash away some color for reflected light. For most of this work, use a no. 2 round brush.

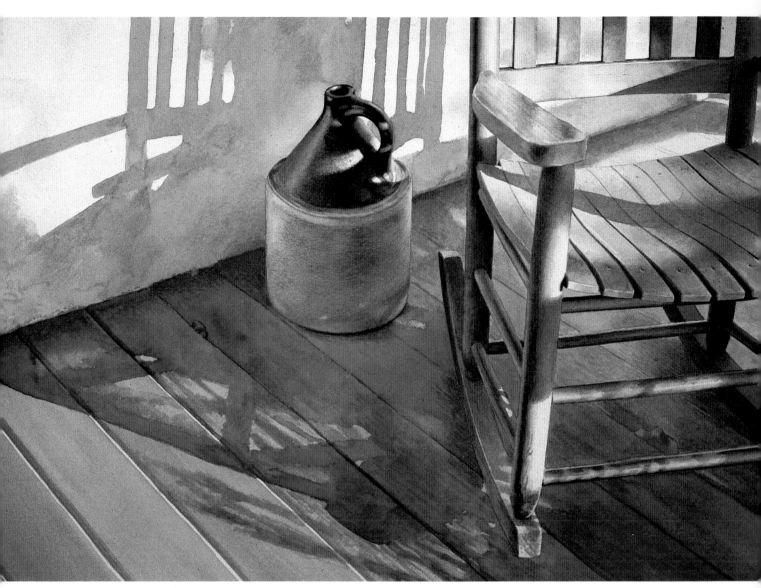

4 Detail the porch floor further with color changes and wood graining, noting nail depressions by washing away specks of color and underlining them with darks. The perpendicular saw marks on some of the boards can be achieved by first washing away color to form the ridges, then accenting the valleys in a deeper tone. Finish the painting by drybrushing more texture onto the irregular surface of the stucco wall.

MICHAEL P. ROCCO
Jug and Rocker
Watercolor, 14" × 21" (36cm × 53cm)

PALETTE
- Lemon Yellow
- Yellow Ochre
- Cerulean Blue
- Alizarin Crimson
- Neutral Tint
- Burnt Sienna
- Warm Sepia

Painting a Wooden Carousel Horse

MICHAEL P. ROCCO

This scene was photographed at night through the display window of a carousel shop. The shop was closed, and there was no sign of human activity within. Yet the carousel horses seemed eager to go on their circular journey at the sound of the bell, galloping slowly up and down to music pumped from a calliope. The artist had always passed by this shop during the day, and while he was impressed by the horses, the scene did not strike a chord until viewed at night. The careful use of highlights and the way you apply the paint are significant to the success of this painting.

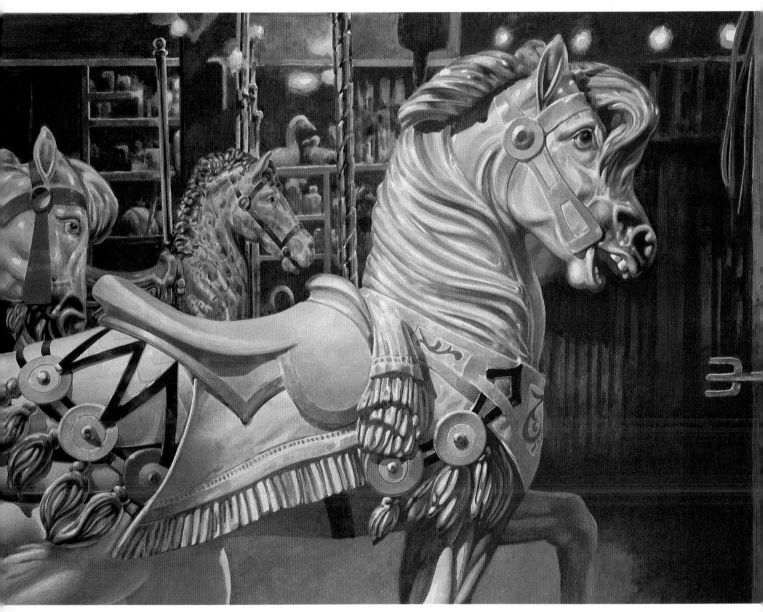

MICHAEL P. ROCCO
The Carousel Shop
Watercolor, 21"×29" (53cm×74cm)

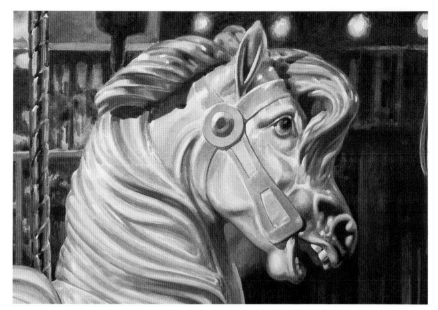

DETAIL OF PAINTED WOODEN CAROUSEL HORSE

1 In painting a subject such as this—one that has a glossy finish—it is important to retain highlights but without overdoing their effect. First, make a very detailed drawing of the horse on tracing paper, then transfer only basic lines to your watercolor sheet initially. Paint the overall color, leaving highlights and decorations clean. Once that is dry, add light shadows and fill some of the decorations with color. Put in the dark background to establish contrasts.

2 Tape your tracing paper drawing in proper position to your watercolor sheet, and transfer additional details to the painting. Using an intermediate tone, paint the shadows of the carved mane with sweeping brushstrokes. This technique is essential to gain the smooth surface of the horse. Put in light shadows to develop the form of the head and flowing hair. Strengthen some shadows, adding to the feeling of dimension. Put in first colors of the mouth and nose.

3 Return the tracing paper drawing to position and transfer final details. Paint slashes of color along with accents of dark, which add to the appearance of a glossy surface. Blend subtle shading into the collar forming it to the horse's chest, then work the ornamental button to its concave shape. Accenting the gold hobnails adds to the dimensional feel. Detail the remaining decorations with the same careful attention. Finish the head with gradually deeper shading, then amplify the effect with darks.

A Critique: *Carousel Chargers*

Artist Douglas Purdon based *Carousel Chargers* on some photographs and sketches he did at a fall fair. He began with a light orange ground of London Red and London Yellow alkyd, then used oils for the rest of the painting. When the painting was close to being finished, the artist critiqued his work and discovered several problems.

COMPOSITION

The small horse on the far left of the painting is too close to the edge; when the painting is framed, it will touch the frame. You lose at least one-quarter inch (.6cm) at the edge of your painting due to the overlap of the frame.

DRAWING

The grid pattern in the background at the right isn't symmetrical and is badly drawn. The mechanical parts at the top aren't straight, and corners are rounded, not square.

COLOR

The red areas on the gray horse are too close in both chroma and value to the red areas on the yellow horse. These areas need to be adjusted to make the yellow horse advance.

VALUE

The values in the foreground are not consistent: The two horses are close in value, yet the gray horse is in shadow. The gray horse needs to be darkened and the yellow horse lightened. The light gray of the canopy at the top of the carousel is close in value to the blue of the sky and tends to blend with it when viewed from a distance.

AMBIANCE

The painting has a cheerful effect, but it could be even more effective once the colors have been intensified by reducing values and with the use of complementary colors in the shadows.

After noting the problems, Purdon began to correct them.

Values too close

Lack of detail and modeling; corners and lines aren't sharp

Drawing mistakes in size and proportion of squares

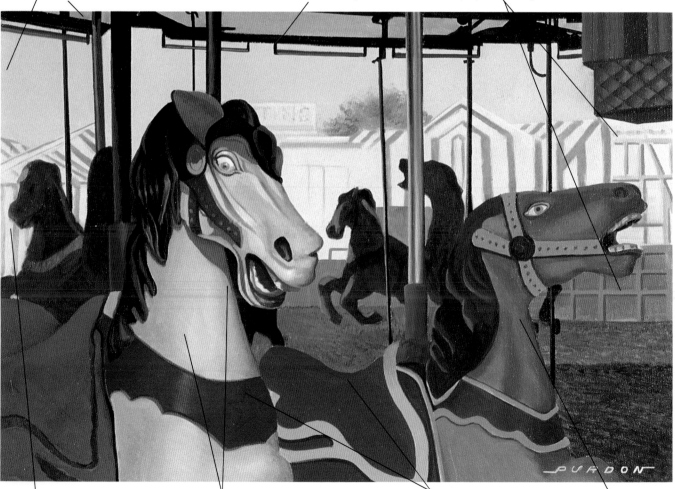

Horse too close to edge of painting

Highlights not bright enough; lack of modeling on form

Reds too close in value and chroma

Values too light to be in shadow

1 ADJUST COMPOSITION

The composition problem was the most difficult to correct. Purdon cut out a drawing of the horse and moved it in different positions to see where it would look best (slightly to the right). He used a sharp knife to scrape off as much of the paint as possible, being careful not to cut the canvas or remove the gesso ground. (It's only necessary to remove the paint where you will be repainting with a lighter color.)

Purdon repainted the horse in the new position and filled in the striped tent in the background. He noticed that the larger area of light value created when the horse was moved was distracting, so he placed a dark fence in front of the horse to act as a visual stop, keeping the viewer's eye from being drawn out of the painting.

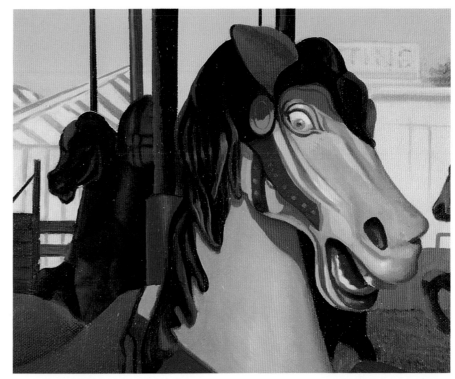

2 REPAINT DRAWING ERRORS

The most noticeable drawing error is the pattern of squares in the right background—they are crooked and unbalanced. If the rest of the painting was done in a sketchy manner this wouldn't matter as much, but if you paint realistically, you must be consistent throughout the painting. When Purdon repainted the pattern, he reduced the intensity of the color slightly so this area would recede. He found the two different patterns of squares distracting, so he overpainted the one at the top and added some stripes so it would blend in with the rest of the background.

The angles and edges of the equipment at the top of the painting needed to be corrected and some details added to develop form, but again the values were kept reduced so this area wouldn't compete with the center of interest. Mixing Titanium White with Dioxazine Purple, Purdon added detail to the neon tubes. The horses in the central background look unfinished, so he corrected the drawing and added some minor details.

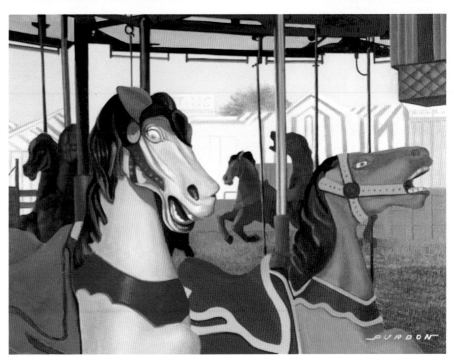

TIP DON'T REPAINT LARGE AREAS

You cannot repaint large areas, as you lose the effects of the toned ground and also risk that the previous work will show through with the passage of time. This effect is called *pentimento* and can be seen in some of the paintings of the Old Masters. In some of Canaletto's paintings the figures that were painted on top of the finished background have turned into transparent "ghosts"—you can see through them.

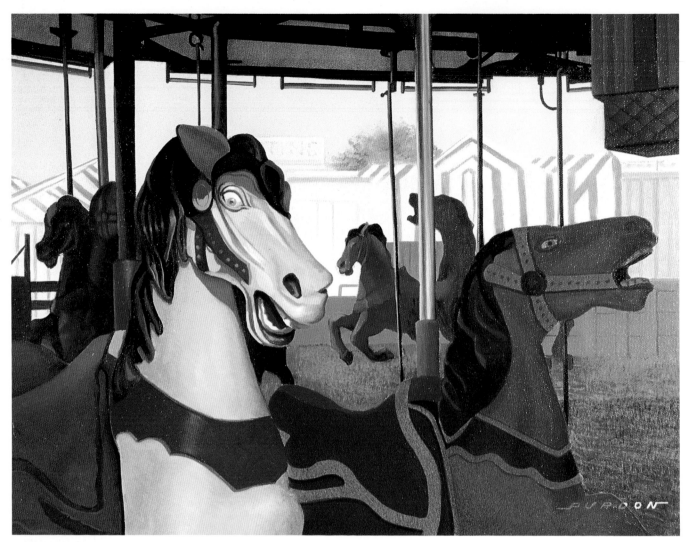

3 CORRECT VALUES WITH GLAZES

The yellow horse is supposed to be the focal point of the painting, yet it seems that the gray horse is too prominent and the painting lacks a dominant center of interest. To correct this, the artist adjusted the values of the gray horse using a glaze. Purdon uses alkyds for glazing because of their drying speed and also because of the brilliance they give to the colors. (You could also use oils.) He made a glaze of Dioxazine Purple and French Ultramarine mixed with Liquin and painted it heavily over the area he wanted to darken. Then, using a blending brush, he removed the glaze until he achieved the desired value. The artist used a blue-purple glaze since it is the complementary color of yellow—this intensifies the yellow horse. He glazed the top of the carousel with French Ultramarine, London Red and London Yellow. He then glazed London Red and French Ultramarine to adjust the modeling of the saddle of the yellow horse, as it looks too flat.

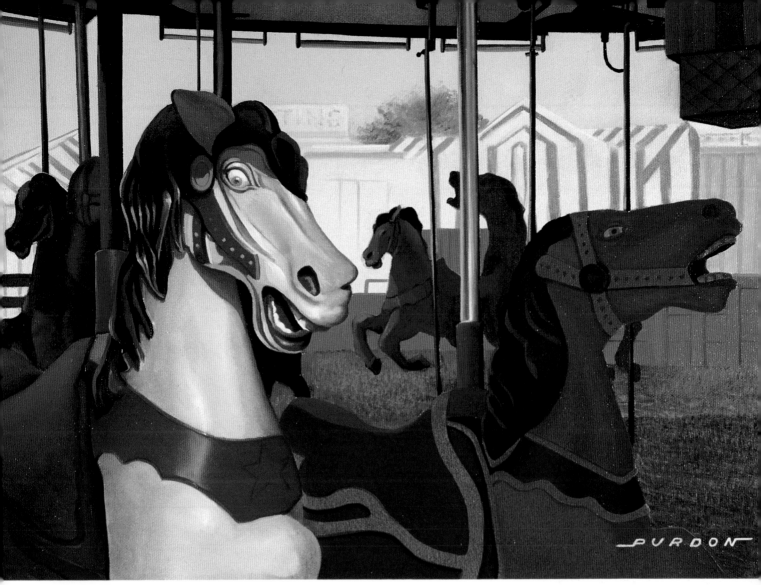

4 BRIGHTEN COLORS AND ADD HIGHLIGHTS

Besides adjusting the value, the glazes have also changed the color. The red areas on the gray horse are now reduced in chroma and move into the background. All the large areas of color have been corrected in chroma and value. The yellow horse looked flat, so Purdon adjusted the modeling using glazes and added highlights with opaque paint. He used a glaze of Alizarin Crimson and Dioxazine Purple to darken the edges and make the form turn. He added some highlights with Titanium White and Cadmium Yellow, and then softened the edges of the highlights with a softening brush.

Mixing a gray from Indigo and Titanium White, Purdon added details and highlights to the yellow horse's mane. He used a semi-opaque glaze of Winsor Blue and Zinc White to give the effect of light catching the saddle and the top of the yellow horse's head. He painted a thin line of Permanent Rose and Titanium White along the bottom edge of the neon tubes, giving the effect of light catching them. Purdon repainted his signature, and the painting was complete.

DOUGLAS PURDON
Carousel Chargers
Oils, 12" × 16" (31cm × 41cm)

Painting Natural Surfaces Outdoors and Indoors

DOUGLAS PURDON
River Torridon and Sgurr Dubh
Oils, 24"×30" (61cm×76cm)
Private collection, Canada

TIP **GO WITH THE FLOW**
When painting a stream, remember the water is flowing and apply the paint in the direction of the flow. Water isn't static; it is a moving entity. Even a still pond will usually have ripples caused by the wind.

Painting Water and Rocks

DOUGLAS PURDON

This painting is based on a snapshot artist Douglas Purdon took on Monhegan Island. "Looking at the photograph, the temptation would be to copy it to the canvas and start to paint," says Purdon. "This would be a mistake! What works for a small snapshot won't work for a large painting." Isolating a section of the photograph for the painting really brings out the textures.

MATERIALS

Oil paints
- English Red
- Cadmium Yellow
- Prussian Blue
- French Ultramarine
- Indigo
- Titanium White
- Burnt Sienna

Acrylic paints (optional)
- Burnt Sienna
- French Ultramarine

Brushes
- No. 4 bristle filbert
- No. 7 bristle filbert
- No. 8 bristle flat
- No. 6 acrylic flat
- No. 0 watercolor round
- No. 2 watercolor round
- No. 6 sable bright
- No. 3 Winsor & Newton Series 240 goat-hair watercolor brush or badger fan blender
- 2-inch (51mm) housepainter's brush

Other
- 24" × 36" (61cm × 91cm) stretched and prepared fine-weave canvas
- Carbon or charcoal pencil
- Liquin
- Mahlstick
- Masking tape
- White soft pastel

Photograph of Lobster Cove. Note how the horizon divides the picture in half.

Drawing made from photograph, with the section selected for the painting indicated.

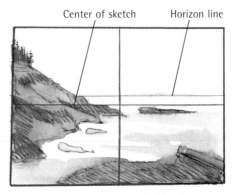

Selected portion of sketch divided into four parts. Horizon is still too close to horizontal center.

Final composition. Horizon moved up and foreground rocks deleted.

1 START WITH PHOTO AND REWORK COMPOSITION

Purdon does an ink-and-wash drawing of the photograph and decides to use only the center portion of the photo. As he marks the area he's planning to use, he notices the horizon divides the picture completely into equal parts. This breaks one of the fundamental rules of composition. If you look at the lower section of the photograph, the land and sea divide the lower part of the painting into equal parts also, making the composition even worse.

Purdon redraws the central portion of the sketch, but this time moves the horizon line slightly above center. When dividing this sketch into four equal parts, he notices there will be one section with nothing but

sky and another with only a small piece of land showing. Adding detail to the sky to make those sections more interesting would detract from the water.

In the next study Purdon moves the horizon up toward the top of the painting, allowing him to add more water. He eliminates the foreground rocks so he can focus on the water. The rocks sloping down into the sea on the left form a strong diagonal statement, so Purdon makes the water form an upward diagonal to cancel the downward slope of the rocks and lead the eye toward the distant rocks out in the water. This will give the painting a feeling of movement.

2 EXPERIMENT WITH COLORS

Purdon places all of his blues on a sheet from a canvas pad and dilutes them with white to see the available colors. Cerulean Blue, Cobalt Turquoise and Thalo Blue are too warm for the mood he wants to set for this painting. He knows from experience that Cobalt Blue has a low tinting strength, so he rules it out, too. Since the predominant color in the painting is blue, he'll use the three remaining blues: French Ultramarine, Prussian Blue and Indigo.

In choosing the reds and yellows, Purdon starts with a color pool using Alizarin Crimson and Cadmium Yellow. He likes the colors he gets with the Cadmium Yellow, but finds the Alizarin Crimson too intense for the subtle mixtures required for the rocks. In the second pool he tries Cadmium Scarlet and Naples Yellow Extra Deep. The Cadmium Scarlet is also too chromatic, and he still likes the Cadmium Yellow better than the Naples Yellow Extra Deep. In the last pool he tries English Red, which is a low-chroma red, and Cadmium Yellow, and he decides to use these colors for the painting.

3 TEST GROUND COLOR

Purdon often tones his canvas with Permanent Rose, Raw Sienna or Burnt Sienna. Since he's not sure which color will work for this painting, he paints all three on a piece of canvas. When dry, he paints the colors for the sky and water over them to see how they will be influenced by the toned ground. He decides to use Burnt Sienna. "Once you become more familiar with the effects created by different grounds, you can probably eliminate this step," Purdon says.

4 BLOCK IN DRAWING

Since there isn't a lot of detail, Purdon sketches the outline from the drawing onto the canvas freehand with a carbon pencil. He keeps the drawing very light so it can be corrected easily and then goes over it with French Ultramarine acrylic paint and blocks in the shapes.

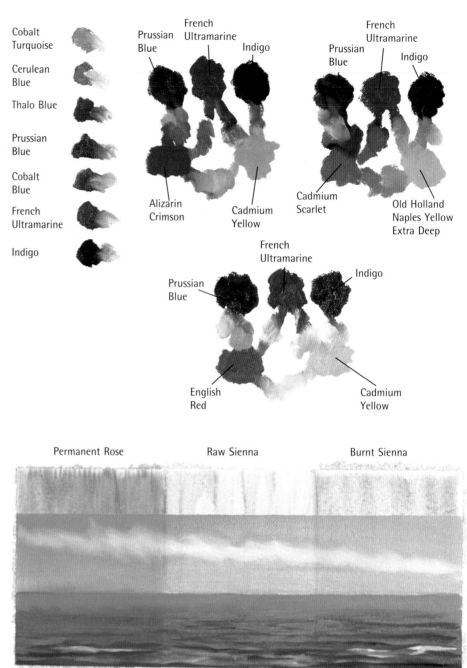

Cobalt Turquoise

Cerulean Blue

Thalo Blue

Prussian Blue

Cobalt Blue

French Ultramarine

Indigo

Prussian Blue — French Ultramarine — Indigo

Alizarin Crimson — Cadmium Yellow

Prussian Blue — French Ultramarine — Indigo

Cadmium Scarlet — Old Holland Naples Yellow Extra Deep

French Ultramarine — Indigo

Prussian Blue

English Red — Cadmium Yellow

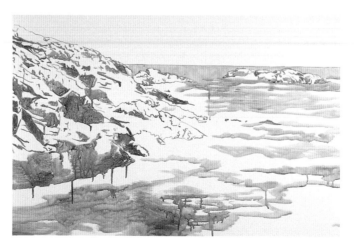

Permanent Rose — Raw Sienna — Burnt Sienna

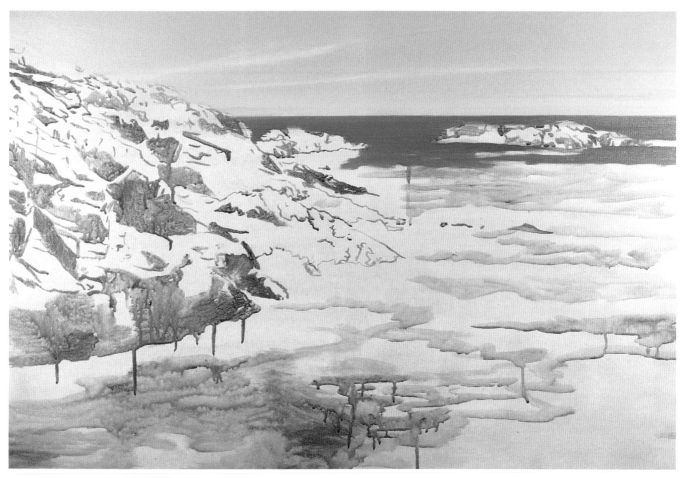

5 TONE CANVAS AND BLOCK IN SKY

Purdon tones the canvas with Burnt Sienna acrylic using a 2-inch (51mm) housepainter's brush. (You could also use a mixture of Burnt Sienna oil, Liquin and mineral spirits.) While the tone is drying, he mixes the colors for the sky and water. The sky color is mixed with French Ultramarine, Prussian Blue and Titanium White. For the distant water, he makes a deeper version of the sky color by adding Prussian Blue. The clouds will be Titanium White, reduced in intensity slightly with the addition of English Red and French Ultramarine and warmed with a very small amount of Cadmium Yellow.

He paints the sky a flat tone, adding just a very small amount of the cloud color at the horizon to lighten it. Then he softens the sky with a no. 3 goat-hair watercolor mop brush, dusting it lightly over the sky to remove and blend paint until the paint is smooth and the ground is starting to show through. He uses a dry no. 4 bristle filbert to lift out some of the sky color, exposing the ground where he wants to paint the clouds. Then he paints the clouds, using less paint on the bottom of the clouds to give the effect of shadow when they are softened. Purdon softens the clouds with a clean no. 3 goat-hair watercolor brush.

Using a mahlstick and a no. 2 watercolor round brush, he paints the horizon line, making sure it is level. He taps a no. 6 sable bright along the edge where the sky meets the water to blend the edge, wipes the brush dry and then draws it along the blend, using the mahlstick as a guide. The edge shouldn't look fuzzy, only soft. Purdon waits for this to dry before doing the next step.

6 BLOCK IN WATER

Purdon mixes up all the colors he thinks he'll need for the water so he won't have to stop painting once he starts. He mixes a middle and light blue, and then straight Prussian Blue with Liquin for the darks. The paint is kept thin to avoid building up ridges of paint that will be hard to cover later.

Using a no. 8 bristle flat, Purdon starts to block in the water. In this painting the strongest contrasts will be in the foreground. As the water recedes, the waves will become smaller and closer together. At this point Purdon just masses in the large forms of the water and captures the feeling of movement, ignoring the small details. Where the sun shines through the water, he adds Cadmium Yellow for the green glow. The areas of foam and spray are left open; he'll paint them when this stage is dry.

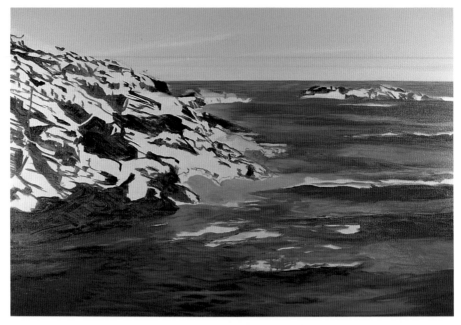

7 PAINT ROCKS

Purdon paints the rocks with a mixture of French Ultramarine, English Red, Cadmium Yellow, Titanium White and Liquin, using a no. 8 bristle flat brush. Then he mixes English Red, French Ultramarine and Titanium White to make a medium gray, and uses this color to underpaint the areas where spray, foam and whitecaps will be added later. He keeps the values in the lower ranges at this stage, as he wants to be able to work from dark to light.

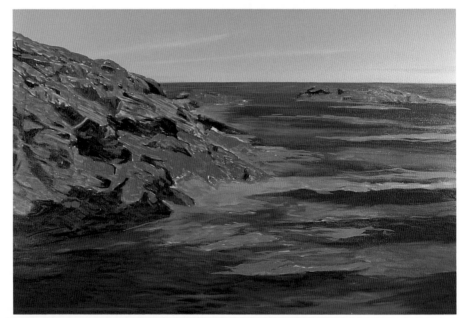

TIP PAINTING WATER

- Keep in mind that water can be either transparent or reflective, depending on the direction of the light.
- Moving water is sculptural—it has form.
- When painting water, keep in mind the rules of perspective, both linear and atmospheric: As things recede they get smaller and the colors become less intense.
- A flat brush is best for painting water—it allows you to "carve" the forms of the waves.
- You should *never* copy water or skies from a photograph, as they end up looking static and lacking life. Both skies and water are full of movement, and you must capture this in your painting to make them believable.

8 DETAIL WATER

Purdon mixes the colors for the water, lightening the values and making them less fluid. Since this paint is of a stiffer consistency, he first applies a very thin coat of Liquin to the canvas to act as a lubricant, easing application and also speeding drying time. Using Titanium White and the colors mixed for the water, he starts to paint the whitecaps and adds details to the water. Purdon keeps the value of the white reduced; this will later serve as an underpainting for the impasto highlights. Next, he develops the rock forms by blocking in the areas of light and dark.

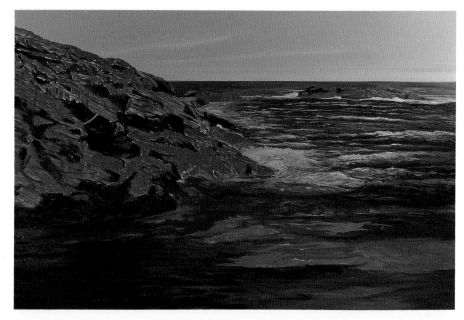

9 DETAIL ROCKS

For the rocks, Purdon mixes various browns and grays using Indigo, English Red, French Ultramarine, Cadmium Yellow and Titanium White, keeping the colors in the middle values and low-chroma range. He starts painting the rocks out in the water and those in the background first, then darkens the sides and adds details to the distant rocks. He paints the highlights using a small watercolor brush. Purdon works toward the foreground, increasing the range of value and detail. Before starting the details on the foreground rocks, he adds texture by painting over the foreground rocks using a transparent glaze of French Ultramarine and Indigo mixed with Liquin and mineral spirits, then blots the glaze with a crumpled paper towel.

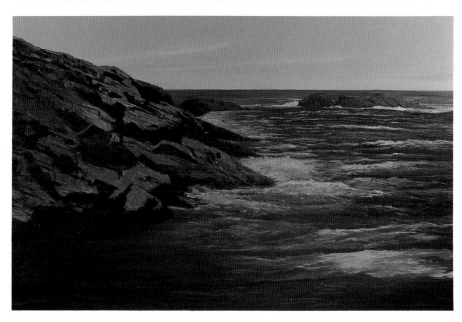

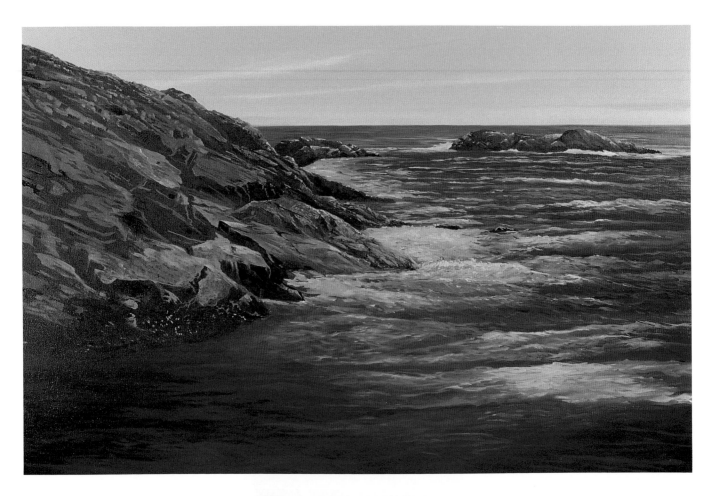

10 CONTINUE DETAILING ROCKS
Now Purdon completes the blocking in of the rocks using slightly lighter and warmer colors than used previously. "If the values seem too light later," he says, "they can be reduced with a glaze once the water is nearer completion." He doesn't want the large areas of shadow to look like holes in the painting, so he adds some details in the shadows with a mixture of Titanium White and French Ultramarine. When dry, he glazes over the shadow areas with mixtures of French Ultramarine and Indigo to give the effect of depth.

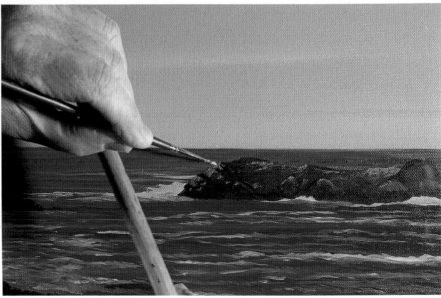

11 TEXTURE ROCKS

Using a transparent glaze of Indigo and French Ultramarine and a worn brush, Purdon adds a broken glaze to the rocks, not covering the previous painting except in the shadow areas. This will give more texture to the rock. You can also add texture by spattering, a technique traditionally used with acrylic or watercolor paints. Purdon mixes a glaze of French Ultramarine, Indigo and Liquin and thins it with a small amount of mineral spirits. He then covers all the areas of the canvas he doesn't want the spatter to reach with newspaper, taping it in place with masking tape. (To weaken the adhesive so it doesn't pull up paint, apply the tape to your clothing and remove it a few times.) Using a stiff-bristled brush, he flicks the brush hairs with his index finger, sending a spray of paint over the rocks. *Always* wear a rubber glove when spattering to avoid contact with the Liquin and mineral spirits.

When he's finished, he uses a small sable flat to soften or remove the larger spatters in the background rocks. "Follow the rules of perspective," Purdon says. "The size of the spatter should decrease as it moves backward in the painting." Using a glaze of French Ultramarine and Cadmium Yellow, he stipples it over the rocks at the waterline to indicate moss. Then he uses mixtures of English Red, French Ultramarine, Indigo, Cadmium Yellow and Titanium White to make minor refinements to the shapes and planes of the rocks, and allows the painting to dry completely before the next step.

TIP USE VARIOUS TECHNIQUES FOR REALISM

When painting rocks, use glazes, spattering and blotting to produce realistic effects. The texture and patterns formed by rocks are created by nature and are therefore abstract and random. Using the above techniques and your imagination, you can paint rocks that are far more realistic than if you had copied them from a photograph.

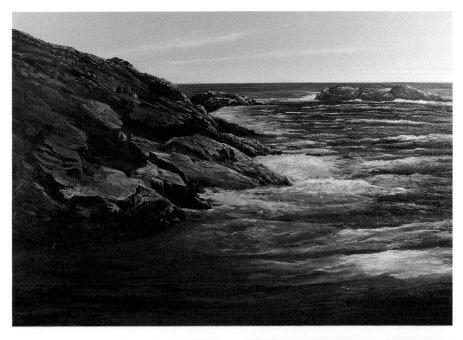

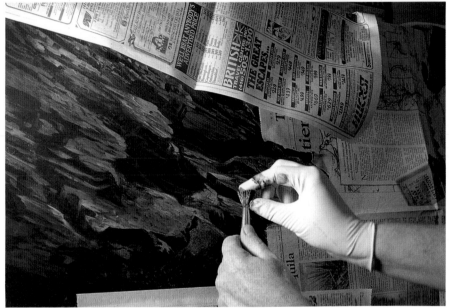

12 REFINE WATER AND ROCKS

Purdon premixes all the colors he's used for the water in previous steps so he can repaint and adjust areas. He mixes a slightly brighter white than the one used in the earlier stages, but doesn't use pure white yet. He also mixes transparent glazes of French Ultramarine, Prussian Blue and Indigo to deepen areas that are too light, then paints detail into the wet glazes.

He starts at the top of the water and works toward the foreground. The bottoms of the rocks in the distance are flat too, so he repaints the waterline to make it look as if they are overlapping. Purdon mixes some Indigo and English Red and thins it with Liquin to add more cracks in the foreground rocks. Using a crumpled paper towel dipped in paint, he adds more texture to the rocks.

He then works on the middle section of the painting, mixing various shades of blue, gray and green to adjust the waves painted earlier. For this stage he uses a no. 2 watercolor round to add fine details. He applies impasto paint for the highlights on the water, then paints a glaze of English Red, Cadmium Yellow and Titanium White over the rocks at the top of the painting to warm them and also to reduce their value slightly. He uses very little white so the rocks don't appear to be in a fog; he just increases their value slightly.

TIP SKETCH DETAILS WITH PASTEL

When faced with the problem of adding detail to a painting, draw the shape lightly on the painting with white pastel. The pastel can be easily removed, yet gives an outline to follow. Pastels mix into the paint, disappearing as you work. When the paint is dry, you can remove any remaining pastel by wiping the area with a damp sponge or rag.

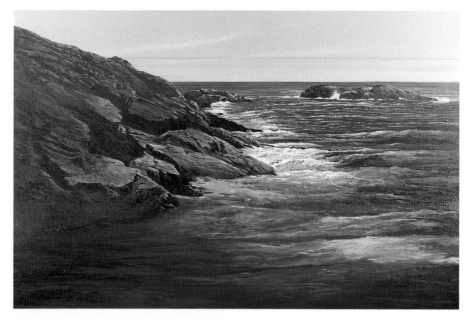

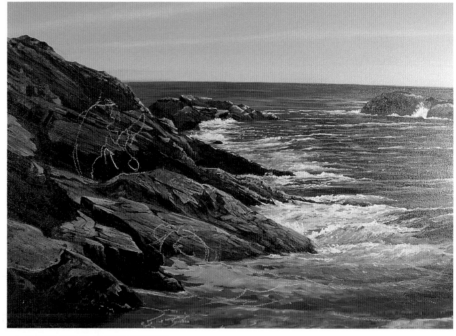

13 SKETCH IN SPRAY SHAPES

Since the next step will be to paint the spray hitting the rocks, Purdon uses a white pastel to sketch in the shape of the spray. You don't want the spray to be too large or symmetrical.

14 START FOAM AND SPRAY

The paint should now be applied impasto so it catches the light. To give the effect of the froth where the sea is meeting the rocks, Purdon gently taps the paint with his index finger, blurring the edge. He starts to paint the spray washing over the rocks; this must be done in several stages so that the paint builds up and catches the light. He then paints the area where the pool of froth will be, softening the edges. "Water produces abstract forms; to make it believable you must keep this in mind while you are painting it," Purdon says. "If it is too structured, it won't look like water."

15 PAINT TREES AND CONTINUE SPRAY

Purdon mixes a variety of greens using Indigo, French Ultramarine, Prussian Blue and Cadmium Yellow. He then paints the pine trees at the top of the rocks. They give a sense of depth and scale to the painting and act as a compositional device, breaking the line of the sky and stopping the viewer's eye from leaving the painting. When the paint starts to dry, he adds highlights to the trees, making sure the values are reduced so they won't jump out of the picture.

Next, Purdon glazes Prussian Blue mixed with Liquin over the foreground water; when the underpainting shines through, it will produce a blue that is far more luminous than could be achieved by mixing the colors on the palette. Due to the high concentration of Liquin, this glaze will start to get tacky quickly. Purdon takes advantage of this by painting the lights and water spray into the glaze using a no. 6 acrylic flat. He paints a glaze of Liquin and a very small amount of French Ultramarine over the spray painted in the previous step—he makes sure the spray is totally dry first or the glaze will dissolve the paint. (Remember that impasto paint, even when mixed with Liquin, will take longer to dry.)

When the French Ultramarine glaze sets—it doesn't have to be completely dry—he paints more droplets of spray using impasto white paint, slightly lowered in value. He uses a no. 0 watercolor round brush to apply each droplet. Purdon allows parts of the spray he glazed with French Ultramarine to show through this application to create depth.

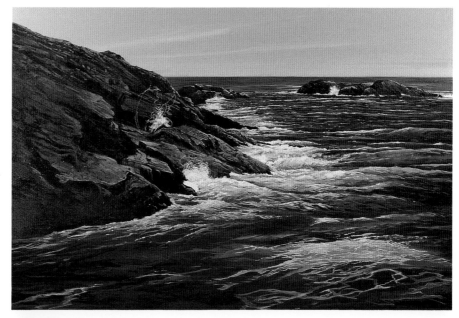

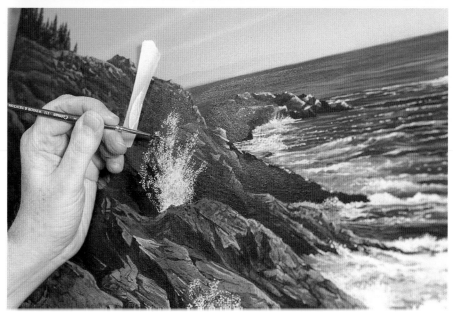

TIP KEEP PAINT HANDY WHEN WORKING SMALL AREAS

When working on a small area of a large painting, Purdon finds it's inconvenient to have to keep going back to the palette for more paint and, since he's usually using a mahlstick, he can't use a handheld palette. He solves the problem by placing a small amount of the paint he's using on a piece of masking tape, then sticking it to the painting near the area he's working on. This way he doesn't have to move his hand or mahlstick to pick up color.

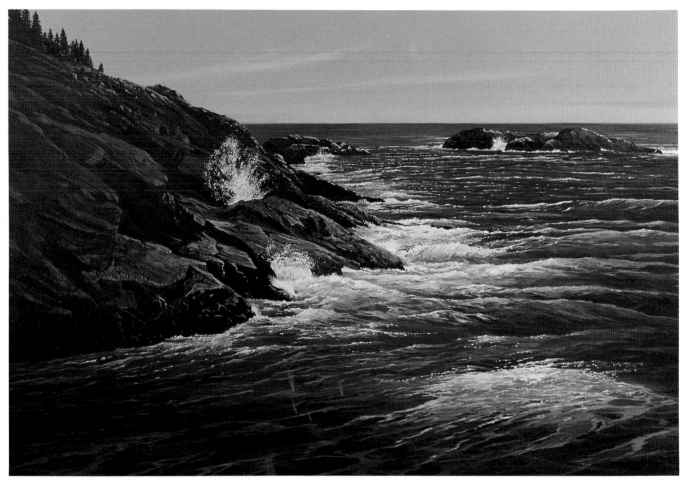

16 FINISH ROCKS AND START WATER SPARKLES

When completed, this painting will consist of a full range of values, from Indigo (which is equal to black) to the full-strength Titanium White reserved for the sparkle on the foam and water. Purdon mixes the local colors for the rocks and uses a no. 0 water-color round to add details to the rocks and indicate some detail where they meet the water. "If the rocks look too light, you can always adjust their value with a glaze later," he says. Using Indigo thinned with Liquin, he adds final details to the rocks. Using

white that is slightly reduced in value, he then starts to add small dots of paint in the middle ground and foreground to give the effect of sparkle on the water.

Except for the addition of the highlights and some final adjustments, the painting is almost finished. He allows the painting to dry for a couple of days before adding the finishing touches. "The night before you plan to finish the painting, mix some pure Titanium White on your palette and allow it to stiffen overnight," Purdon says.

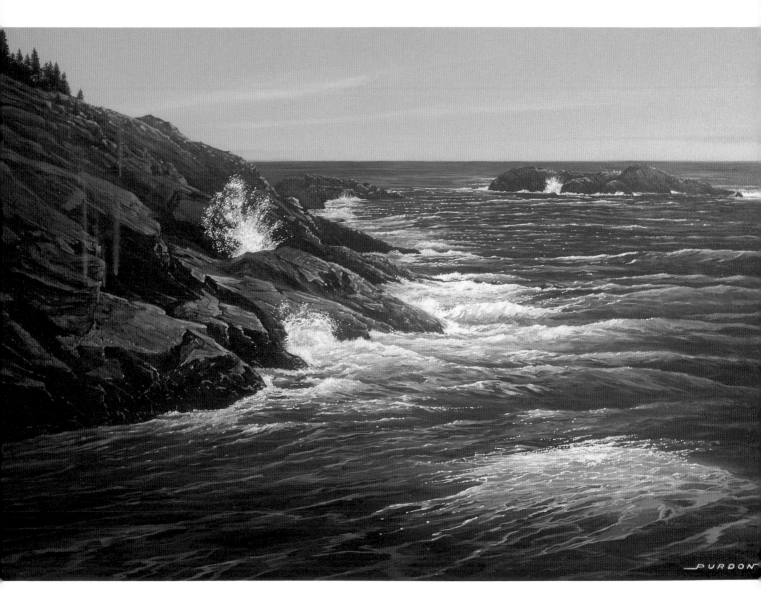

17 FINE-TUNE

Purdon puts the painting back on the easel and takes a long, critical look at it to see where adjustments can be made. These adjustments will be made using impasto paint that will catch the light. Up until now he has not used pure white—now is the time to use the white he allowed to stiffen overnight to add the final sparkle to the water and spray so they will come forward in the painting. The rocks in the background need to be lessened in value slightly; this can be accomplished with a milky glaze of Titanium White, English Red and French Ultramarine. "This must be done carefully; if you lighten the rocks too much, you will upset the balance of values in the painting," Purdon says. At the same time, he glazes the highlights of the rocks in the background with a glaze of Indigo and English Red to reduce their value slightly. Once these minor adjustments are made, the painting is finished.

DOUGLAS PURDON

Lobster Cove

Oils and acrylic, 24"×36" (61cm×91cm)

Painting the Textures of Fruit

JUDY D. TREMAN

1 MAKE DRAWING

Begin sketching with a no. 2 pencil and make your final drawing with a no. 6 pencil. Apply frisket to small areas of white you want to save, including highlights on each piece of fruit and the glass bowl, as well as embroidery stitches on the quilt. You can paint around bigger areas of white, such as the peeled part of the apple.

2 APPLY SHADOW GLAZES

Now apply the shadows with transparent glazes of various hues and intensities of purple, depending on the local color. Paint shadows using a mixture of French Ultramarine and Permanent Rose. For the darkest shadows, use Permanent Alizarin Crimson with French Ultramarine. Use a warmer (redder) mixture for the shadows on the peaches and plums and a cooler (bluer) shadow on the apple and grapes. At this stage you can see all the contours and shapes taking form. Let this first glaze dry completely before doing the next layer.

MATERIALS

Winsor & Newton paints
- Winsor Lemon
- Winsor Yellow
- Aureolin
- Scarlet Lake
- Winsor Red
- Permanent Alizarin Crimson
- Permanent Rose
- Rose Madder Genuine
- French Ultramarine
- Viridian
- Hooker's Green

Other
- 300-lb (640gsm) rough watercolor paper
- Nos. 3, 5, 7 round sable brushes
- Frisket
- Nos. 2 (soft) and 6 (hard) pencils
- Very gentle eraser

3 ADD YELLOW PEACH GLAZES

Paint a transparent yellow glaze on the peaches over the reddish purple shadows using a mixture of Aureolin and a touch of Winsor Red or Permanent Rose. Paint the glaze in only one stroke so you do not lift the violet shadow underneath. Paint an intense version of the color in shadow areas, and add water to dilute the color near the highlights. Let dry.

4 DEVELOP PEACHES AND PLUMS

Now glaze another transparent layer for the reddish blush of the peaches over the yellow glaze by adding more Winsor Red to the Aureolin glazing mixture. Paint the local color from light to dark, warm over warm. Finally, add a little Permanent Alizarin Crimson to create the darkest blush of the peaches. Paint a glaze over the plum shadows with a mixture of Permanent Alizarin Crimson and French Ultramarine.

5 GLAZE GRAPES AND APPLE

Working cool over cool, use a mix of Winsor Lemon, a touch of Hooker's Green and a tad of Scarlet Lake to paint the grapes and the apple. Glaze over the cool, bluish purple shadows of the grapes one by one. Painting alternate grapes and allowing them to dry speeds up the process. Vary the colors of the grapes. Add a drop of water in the center of each grape to push the color pigment away from the highlights. Paint the apple, washing the color away from the highlight. Be careful to keep subtle, gentle greens.

The completed detail shot of *Riches of Summer*, which appears in its entirety on the next two pages.

6 FINAL DETAILS

Transparent color allows each layer of glazing to shine. Building up layers adds to the richness and believability of the painting. Opaque colors do not work for this kind of building up of layers of colors. Frisket saves the etched pattern in the glass bowl, and a soft gray glaze of French Ultramarine dulled with a little Permanent Alizarin Crimson finishes the effect.

USING GLAZES SUCCESSFULLY FOR TEXTURE

Keep these tips in mind to get the best results from using glazes to create texture:

• Building up layers of color with glazes is a good way to create shadows (which give a strong design to the painting) and still retain beautiful colors.

• Glazes are useful for producing translucence, interesting textures and luscious blended colors in your watercolors.

• Use transparent colors to keep your colors unclouded and to take advantage of the power of white paper.

• Paint only one stroke over each layer of glazing, because a second stroke will lift the preceding layer.

• You can glaze many times, but allow each layer to dry completely before painting the next layer.

• Build glazes from light to dark.

• Glaze warm colors over warm and cool over cool.

• Use a high-quality, soft round sable brush and 300-lb. (640gsm) rough or cold-press paper to increase your likelihood of success with glazes.

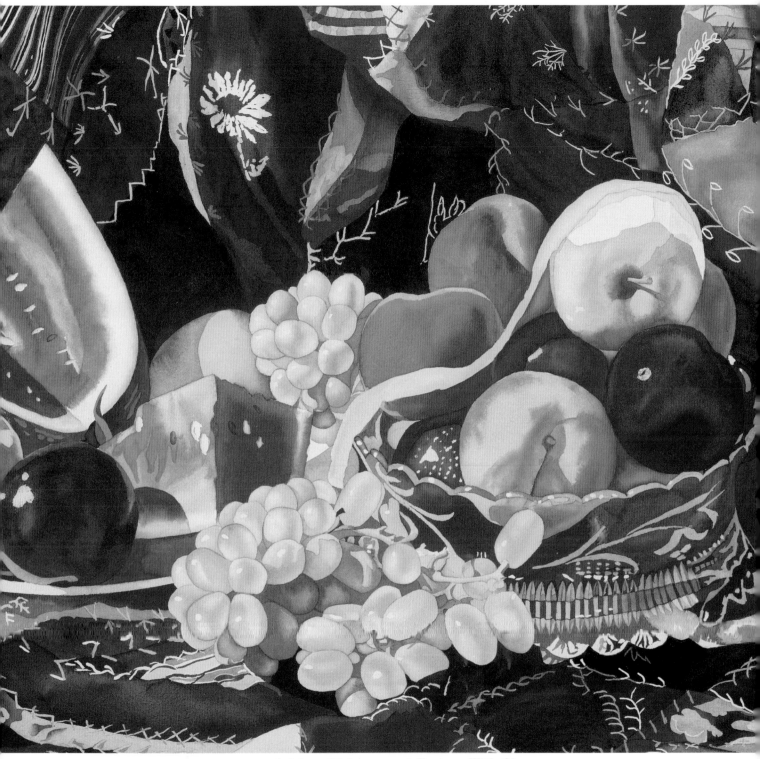

JUDY D. TREMAN
Riches of Summer
Watercolor, 27½″ × 39″ (70cm × 99cm)
Collection of the artist

Achieve Richness and Texture With Glazes

White paper shining through the many layers of glazes helps give a power boost to the glowing colors of *Riches of Summer*. The colors of the fruit simply cannot be achieved with one layer. Shadows give the apples, grapes and peaches convincing realism. Purple plums relate the foreground to the background. The cut watermelon makes viewers drool! Glazing helps to achieve the rich colors and textural qualities of the fruit, from the shiny plumpness of each grape to the delicate softness of peach fuzz.

Painting Various Textures and Surfaces

Painting Recyclable Plastic

LISA BUCK-GOLDSTEIN

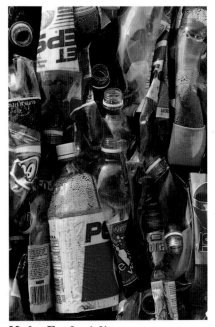

Make Early Adjustments
This photo was taken at a recycling center. The Pepsi bottle is dominant and is a very unpleasant shape. The artist corrected this by crushing the bottle's side in her drawing, giving the shape more movement and sensuality.

1 MAKE DRAWING
Create a drawing based on the reference photo, making adjustments as desired. Notice how much rounder and more playful the artist has made the lines, especially in the Pepsi bottles. Twisted lines really twist, and the folds are simplified and exaggerated.

MATERIALS

Paints
- Naples Yellow
- Medium Magenta
- Cerulean Blue
- Cobalt Blue
- Phthalo Blue
- Phthalo Green
- Dioxazine Purple
- Mars Black
- Quinacridone Violet
- Cadmium Red
- Yellow Ochre

Brushes
- 1-inch (25mm) flat synthetic
- No. 8 round watercolor
- No. 4 or no. 5 round Winsor & Newton Sceptre Gold watercolor

Other
- Acrylic flow improver solution
- Gel medium

TIP BEGIN WITH FOUR COLORS

Because acrylic paints dry so quickly, only place these four colors on your palette for the first step:
- Naples Yellow
- Medium Magenta
- Cerulean Blue
- Cobalt Blue

Add other colors as you need them during the painting process.

2 SET INITIAL WASH

Use a 1-inch (25mm) flat synthetic brush in broad overlapping strokes for the underpainting. Color placement is not as important as the even-glowing, constantly changing color. This glaze contributes to the connected quality of the finished painting.

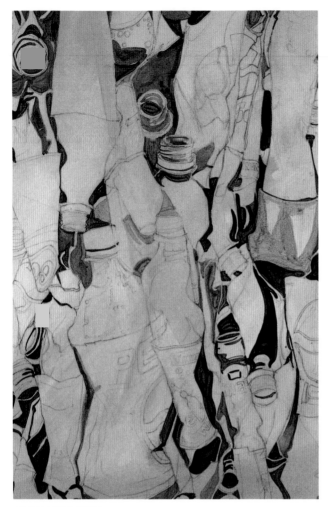

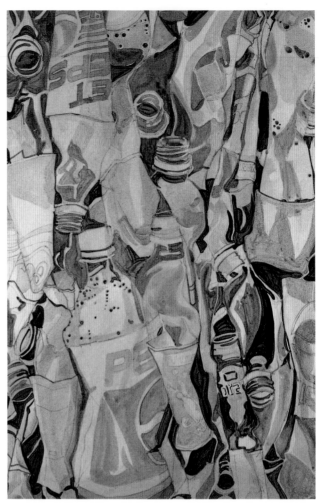

3 LAY IN DARKS

The darkest areas of this painting are the foundation upon which all other colors are built. Mix the darks at 90 percent full value. To keep the colors clear and unclouded, use only staining colors. The idea is to paint all the darks in one value, but not in one color. For example, you might start by mixing Phthalo Blue, Phthalo Green and Dioxazine Purple thinned with flow improver solution. The next time you load your brush, mix in some Mars Black, reload it, and mix a new dark of Phthalo Blue, Quinacridone Violet and Mars Black. Never mix the darks the same way twice—always maintain their value.

By now, you should have laid out all your dark colors on the palette. Next, take a no. 8 round watercolor brush, load it with clean flow improver solution and add a drop of water to each color. This does not dilute the pigment, and it keeps the paint moist, soft and pliable for several hours.

4 DO VALUE STUDY

As you continue to paint the darks, start to thin the colors with flow improver and paint in your value study. The value study is the blueprint for the rest of the painting. Add the following colors to your palette: Naples Yellow, Cerulean Blue and Medium Magenta. The light patterns are established, as well as the placement of highlights and middle values.

TIP USING ACRYLIC FLOW IMPROVER

In a half-pint (2dl) container, mix one part acrylic flow improver to twenty parts water. Acrylic flow improver increases flow of acrylic colors with minimal loss of color strength and is especially useful for hard-edge painting techniques. For opaque brushwork, you can use the tube paint with the flow improver solution alone. For a wash, thin the pigment with the flow improver solution and some water or gel medium. It should be clear and about the consistency of milk.

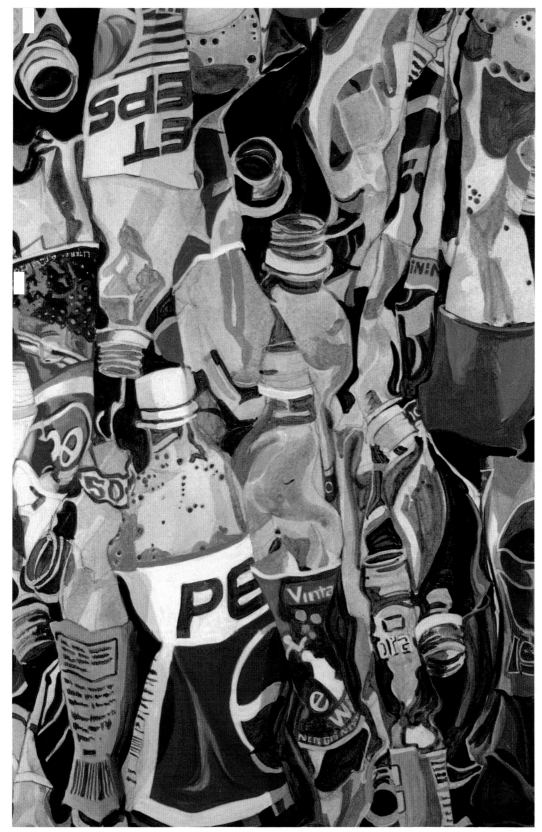

5 CREATE FULL PALETTE OF COLORS

Clean the old paint off the palette and mixing area. Fill in the largest areas of color next, using a no. 4 or no. 5 round Winsor & Newton Sceptre Gold watercolor brush. Note the large areas of red, Cerulean Blue and dark blues and greens.

6 DETAIL: WORK ON SMALL AREAS

Here's a close-up of a typical section of bottle. Work on one area until it is right. Working on a small area at a time allows you to blend the most edges of paint. Once you have the darks in place, paint the highlights and white cap ring. Small areas of reflected green color are suggested.

7 DETAIL: BUILD HIGHLIGHTS

Start to build up the highlights on the bottle neck. Use thicker paint to emphasize the brightness. Block in the lightest values of Cerulean Blue, green and yellow. Mix gel medium with highlights to achieve correct consistency.

8 DETAIL: LAYER IN MIDDLE VALUES

There is a lot of reflected color on this bottle. Notice all the speckles of green. The entire area must be covered with paint. With the darks and highlights painted, you can layer in your middle values, designing and redesigning the shapes.

LISA BUCK-GOLDSTEIN
Bottleneck
Acrylic, 13¾″×21″
(35cm×53cm)

9 ADD FINAL TOUCHES

Pick up brushloads of pure pigment on your small brush and add small specks of accent strokes where they are needed: a drop of pure Cadmium Red on a yellow label, bright Yellow Ochre on a bead of water, Cerulean Blue on the lip of a bottle neck. All these colors appear elsewhere, but by accenting dark areas or highlighting a dull edge, the painting becomes connected and the eye moves around smoothly.

Porcelain

GARY GREENE

Painting ceramic or porcelain surfaces is similar to painting glass, except that these surfaces are opaque.

1 Layer Tuscan Red, Henna (darkest hues only), Raspberry and Magenta. Leave highlight areas free of color.

2 Burnish White.

3 Layer Raspberry (darkest hues only). Burnish Magenta. Burnish White (secondary highlights only). Clean up rough edges with Magenta Verithin. Repeat steps 2 and 3 if necessary.

PALETTE
Sanford Prismacolor pencils
- Tuscan Red
- Henna
- Raspberry
- Magenta
- White

Sanford Verithin pencil in Magenta

Rust

1 Layer Pumpkin Orange and leave rivets and peeling paint free of pigment.

2 Wash with rubber cement thinner and a small brush.

3 Layer Dark Umber, Tuscan Red, Terra Cotta, Light Umber and Mineral Orange.

4 Dab with rubber cement thinner and a small brush. Repeat Step 3 as required.

5 Complete rivets using steps 1-4.

6 For the peeling paint, layer Goldenrod and burnish Sunburst Yellow.

7 Layer/burnish shadow areas with French Grey 90% and Black Verithin. Sharpen edges with Terra Cotta Verithin and Black Verithin.

MATERIALS
Sanford Prismacolor pencils
- Pumpkin Orange
- Dark Umber
- Tuscan Red
- Terra Cotta
- Light Umber
- Mineral Orange
- French Grey 90%
- Goldenrod
- Sunburst Yellow

Sanford Verithin pencils
- Terra Cotta
- Black

Other
- Small brush
- Rubber cement thinner

Paper Bag

The primary consideration in painting paper is that the "wrinkles" have sharp, well-defined edges, as opposed to cloth, which has smooth, soft folds.

1 Layer Sand, then wash with rubber cement thinner and a cotton swab.

2 Layer Light Umber, then wash with rubber cement thinner and a cotton swab.

3 Repeat Step 2, then develop creases by erasing and layering/burnishing Light Umber. Wash with rubber cement thinner and a small brush. Repeat as necessary. Add French Grey 90% to darkest values only.

MATERIALS
Design Spectracolor pencil in Sand
Sanford Prismacolor pencils
 • Light Umber
 • French Grey 90%
Other
 • Rubber cement thinner
 • Cotton swabs
 • Small brush

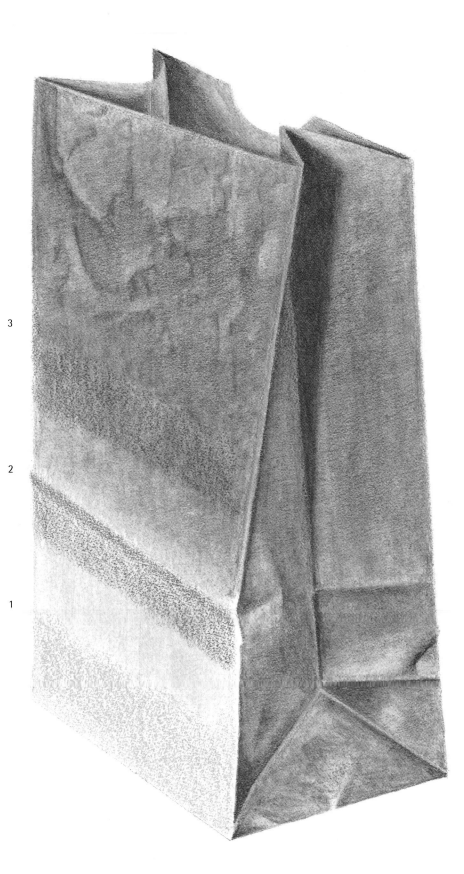

Rubber Balloon

The balloon's surface is not as reflective as glass or porcelain. To achieve this effect, burnish the highlight area with white instead of allowing the paper surface to show through.

1 Layer Tuscan Red (darkest values only), Crimson Lake, Crimson Red, Scarlet Lake and Poppy Red. Leave highlight area free of color.

2 Burnish White.

3 Layer/burnish Scarlet Lake (darkest areas only). Burnish Poppy Red and White. Drag color into highlight area with White. Sharpen edges with Tuscan Red Verithin and Carmine Red Verithin.

PALETTE

Sanford Prismacolor pencils
- Tuscan Red
- Crimson Red
- Scarlet Lake
- Poppy Red
- White

Design Spectracolor pencil in Crimson Lake

Sanford Verithin pencils
- Tuscan Red
- Carmine Red

Shiny Cloth

Allowing the white of the paper surface to show through for the highlights and burnishing adjacent to them with white only will help you realistically depict the texture of any shiny cloth.

1 Layer, in gradations, Process Red (darkest values only), Hot Pink, Pink and Deco Pink. Leave paper free of color for highlights.

2 Burnish White.

3 Layer Hot Pink (darkest values only) and Pink. Burnish Deco Pink and White (secondary highlight areas). Sharpen edges with Pink Verithin.

PALETTE
Sanford Prismacolor pencils
- Process Red
- Hot Pink
- Pink
- Deco Pink
- White
Sanford Verithin pencil in Pink

Dull Cloth

Angular hatch strokes help make cloth texture look more realistic. A circle template was used to lay out the rivets.

MATERIALS

Sanford Prismacolor pencils
- Cloud Blue
- Cool Grey 90%
- Indigo Blue
- Violet Blue
- Periwinkle
- Sienna Brown
- Light Umber
- Yellowed Orange
- White

Sanford Verithin pencils
- Orange
- Yellow Ochre

Other
- Rubber cement thinner
- Cotton swabs
- Electric eraser with imbibed eraser strip

1 Using angular strokes, layer Cloud Blue.

2 Using angular strokes, wash with rubber cement thinner and a cotton swab.

3 Using angular strokes, layer Cool Grey 90% (darkest value bottom waist seam only), Indigo Blue, Violet Blue, Periwinkle and Cloud Blue. Leave rivet area free of color.

4 With a sharpened imbibed eraser strip in an electric eraser, carefully erase a thin line for stitching.

5 For stitches burnish Orange Verithin and Yellow Ochre Verithin in dash pattern. Burnish White. Re-layer around stitches with blue.

6 Layer rivets as shown with Sienna Brown and Light Umber. Burnish Yellowed Orange.

Bricks and Mortar

Bricks are not all exactly alike, so vary the amount of each color from brick to brick.

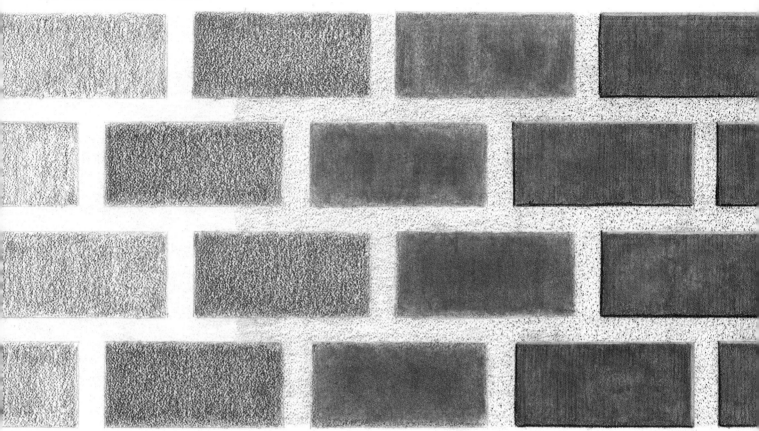

Mortar

1 Layer Cool Grey 10% using circular strokes.

2 Layer Cool Grey 50% using circular strokes and a flattened point.

3 Stipple Cool Grey 90% randomly

Bricks

1 Layer Terra Cotta, Indian Red and Pumpkin Orange using vertical strokes.

2 Wash with rubber cement thinner and a cotton swab using vertical strokes. A small brush may be substituted around the edges

3 Layer Tuscan Red using vertical strokes. Randomly tap lightly with a kneaded eraser. Lightly re-layer Pumpkin Orange using vertical strokes. Clean up rough edges with Terra Cotta Verithin. Highlight with Dark Umber at bottom left and White at top right.

MATERIALS

Sanford Prismacolor pencils
- Terra Cotta
- Pumpkin Orange
- Tuscan Red
- Dark Umber
- Cool Grey 10%
- Cool Grey 50%
- Cool Grey 90%
- White

Sanford Verithin pencil in Terra Cotta

Lyra Rembrandt Polycolor pencil in Indian Red

Other
- Rubber cement thinner
- Cotton swabs
- Small brush
- Kneaded eraser

Wicker

Goldenrod

Jasmine

Cream

MATERIALS
Design Spectracolor pencil in Sand
Sanford Prismacolor pencils
 • Light Peach
 • Goldenrod
 • Jasmine
 • Cream
Other
 • Rubber cement thinner
 • Cotton swabs

1 Layer entire area with Sand and Light Peach.

2 Wash with rubber cement thinner and a cotton swab.

3 Layer/burnish Goldenrod in darkest areas.

4 Burnish Cream (lightest areas). Burnish Jasmine (secondary shadow areas).

Achieving a Velvetlike Finish

PHIL CHALK
Covenant
Acrylic, 36″×46″ (91cm×117cm)

THIN ACRYLIC GLAZES WITH AN AIRBRUSH

Airbrushing is a technique often associated with commercial art. Some artists use it for smooth application of backgrounds in their paintings. And some, like Phil Chalk, create sensitive paintings with the airbrush, often in combination with other tools and mediums.

Chalk relies heavily on glazing for his finished effect, using an airbrush. He chooses acrylic as his medium over slow-drying oils because he likes shooting thin layers of fast-drying paint. He also enjoys glazing with thin washes without disturbing the underlayer of paint (a virtual impossibility with watercolor).

Mistakes with the airbrush (unless caught early in the process) are not so easily corrected because of the velvetlike finish Chalk achieves. Because of this and because his work is so exacting, Chalk relies heavily on his drawing ability to establish a clear guide for his multiple paint applications.

Among the many pitfalls of airbrush use is the likelihood that your paint mixtures will not look the same when sprayed onto the painting surface as they do in the jar. Therefore, it's always wise to test them before applying. The airbrush artist needs an astute understanding of the workings of color—and, of course, good equipment and a willingness to experiment.

Painting Contrasting Textures

PHIL CHALK

Phil Chalk's technique is to mix a rather thick concoction of paint with matte or gloss varnish. Using twenty pounds of air pressure coupled with the thick consistency of his paint allows Chalk to work very close to his support without fear of his paint "fan ning out." Of his chosen technique Chalk says, "Most fine-art airbrush work makes airbrush users look like they are only interested in cheap tricks and slick commercial images," whereas "a combination of airbrush *and* other tools is always more interesting and unique." Thus, beyond his expert handling of air, Chalk adeptly brings his work to completion with paintbrushes and Sanford Prismacolor pencils. This mixed media application helps Chalk to achieve the textures he's after.

Extensive Planning

Referring to slides such as the one pictured here, and also drawing from life, Chalk has this composition planned, mapped out and drawn in twenty-five hours.

Contour Drawing

Next, Chalk makes a contour drawing of each of the many objects in the composition. These drawings are done on drafting film (rag paper), which he then coats on the back with graphite. The drawings are positioned on the support and transferred to it by retracing with a hard pencil.

1 After the drawing is transferred and toned down with a kneaded eraser, Chalk begins to block in the dominant background color. Using the airbrush freehand and barely pressing on the trigger, Chalk draws in the color very close to the outlines of his forms. This method, he says, "keeps most of the overspray from discoloring the areas that have yet to be painted. As I work away from these white areas, I begin to pull back on the trigger more to get wider lines that are easier to blend."

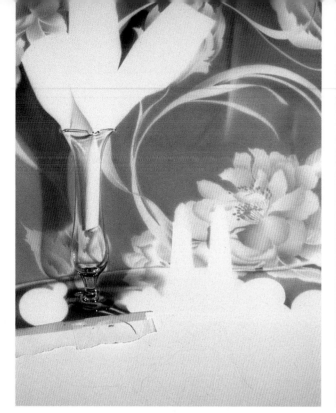

2 After completing the fabric colors, Chalk starts working on other patterns, such as the flowers and vines. Once he has fine-tuned the background, he begins to render the crisp foreground objects, protecting the softer background with tape and paper masking.

3 Chalk now focuses on the eggs, which he freehands, using Cool Violet and Warm Violet with pure Ultramarine Blue for modeling the forms by means of shadows. A light wash of Raw Sienna on the lighted side enhances the roundness. Working in the lower left, Chalk masks off an egg to prevent overspray. "The flower petals and leaves that are closest to the egg and along the edge of the fabric are painted while holding up a curved piece of card stock to make hard edges and control overspray," he says. This technique is called "shielding."

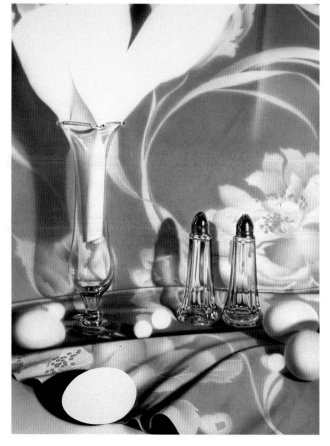

4 The shadows and the white table in the corner have been completed, as has the fabric around the egg (except for fine detailing with brushes). After pulling off the frisket that was masking the egg, Chalk applies the negative shape of the frisket that surrounds the egg. This will protect the bordering areas as the egg is sprayed with paint.

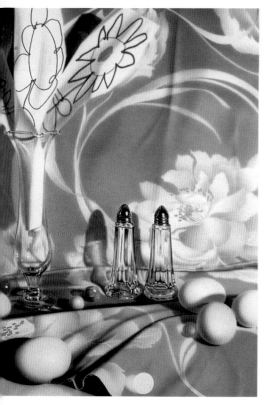

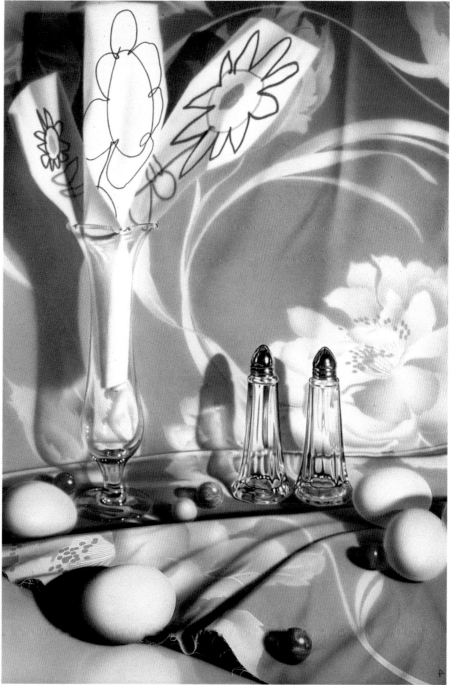

5 Chalk begins to paint the paper flowers using bright, pure tube colors, and models the folds in the paper with the shadow colors he mixed in Step 3. After studying the composition for a day, Chalk makes his decisions regarding the color and color temperature of the marbles. He chooses warm colors for those in the foreground and cool colors for the background ones, explaining, "This, I felt, was a more natural way to create a visual movement that led up to the bright flowers, since warmer colors advance and cooler ones recede."

PHIL CHALK
Seraiah's Bouquet
Acrylic and colored pencil
40″ × 30″ (102cm × 76cm)

Finish

"I studied the painting for several days and added a few polishing touches before signing it and calling it done," Chalk says. *Seraiah's Bouquet* took about 155 hours to complete, counting the drawing time.

INDEX